PHOTOGRAPHER'S GUIDE TO

Yellowstone and the Tetons

JOSEPH K. LANGE

STACKPOLE BOOKS

For my parents, Lois and Ken,
who introduced me to Yellowstone and the Tetons

Copyright © 2000 by Stackpole Books

Published by
STACKPOLE BOOKS
5067 Ritter Road
Mechanicsburg, PA 17055
www.stackpolebooks.com

Printed in China

Cover design by Wendy A. Reynolds
Cover photos by Joseph K. Lange
 front: *Old Faithful eruption in winter, Yellowstone National Park*
 back: *Mt. Moran and aspen, Grand Teton National Park*

10 9 8 7 6 5 4 3 2 1

First edition

Library of Congress Cataloging-in-Publication Data

Lange, Joseph K.
 Photographer's Guide to Yellowstone and the Tetons / Joseph K. Lange
 p. cm.
 Includes bibliographical references.
 ISBN 0-8117-2895-1 (alk. paper)
 1. Yellowstone National Park—Guidebooks. 2. Grand Teton National
Park (Wyo.)—Guidebooks. 3. Photography—Yellowstone National Park—
Guidebooks. 4. Photography—Wyoming—Grand Teton National Park—
Guidebooks. I. Title.

F722 .L27 2000
779'.99178752 21—dc21 99-043766

CONTENTS

PREFACE

My interest in Yellowstone and the Tetons began at the age of ten, when my family, who lived in a Chicago suburb, vacationed in these parks. I found the beautiful scenery, thermal features, and fields of flowers new and interesting. Wildlife was abundant, and back in the 1950s, when I was being introduced to these parks, bears were everywhere. On one visit, I counted over one hundred bears.

I wanted to record the beauties of this fascinating area. My mother, an art teacher, had taught me the principles of composition and the basics of drawing and painting. However, I didn't have the patience to spend a long time on one work of art. I had seen the beautiful landscapes of Ansel Adams, and I decided that photography would be my chosen form of artistic expression. So, on our next trip west, I took along a Kodak Pony camera with adjustable focus, shutter speed, and aperture and taxed my father's patience with requests to stop and photograph everything.

Over the years, my appreciation and knowledge of Yellowstone and the Tetons have grown. I've photographed in each park at all seasons of the year, each of which has its own unique beauty and photographic opportunities. For the last nine years, I've led two or three photographic workshops to Yellowstone and the Tetons each year.

In the *Photographer's Guide to Yellowstone and the Tetons,* I reveal my favorite photographic locations in each park and give advice on when and how the best pictures can be obtained. The history, ecology, botany, geology, and zoology of Yellowstone and the Tetons are beyond the scope of this book. For more details on these interesting subjects, I recommend *Yellowstone: A Visitor's Companion,* by George Wuerthner (Stackpole Books, 1992).

This book also does not cover the basic artistic and technical aspects of nature photography. It is geared for the advanced amateur who already understands basic photography. For more basic information on composition, lighting, exposure, and equipment, see *How to Photograph Landscapes* (Stackpole Books, 1998).

I would like to thank Mark Allison and David Richwine, my editors at Stackpole, for their assistance in turning my rough manuscript into a helpful and informative book. Their good cheer and constructive comments made writing it a pleasure.

Why to Photograph in Yellowstone and the Tetons

Yellowstone and the Grand Tetons have the greatest concentration of varied and spectacular nature subject material of any area in the United States—maybe even the world. Only three other areas on earth—Siberia, New Zealand, and Iceland—have a significant concentration of thermal features. Yellowstone has by far the largest and most spectacular assemblage of geysers, hot springs, mud pots, terraces, and fumaroles. The shapes, colors, and patterns associated with these features challenge the photographer's compositional skills. The eruptions of the hundreds of geysers in Yellowstone present a symphony of action and form. Some are powerful and others are delicate, but most make interesting photographic subjects. Dramatic and varied lighting may occur, depending on the vantage point and time of day or year. The runoff streams that flow from the geysers and hot springs are colorful, interesting, and ever changing. Algae and bacteria in Yellowstone's many hot pools, terraces, and runoff streams create a kaleidoscope of yellows, oranges, reds, and browns. If the water is too hot for these organisms to grow, the pool reflects the color of the sky.

Yellowstone also has an outstanding number, quality, and variety of waterfalls. This high volcanic plateau receives large amounts of moisture in the form of winter snows and summer rains. Runoff from the rugged terrain feeds numerous rushing streams. Smaller streams have graceful, lacy cascades. More powerful waterfalls are found on some of the major rivers and streams. The combination of thermal activity and the cutting action of the Yellowstone River has formed the colorful and spectacular Grand Canyon of the Yellowstone River.

In Yellowstone, unexpected photographic opportunities abound. Due to widespread thermal activity, high elevations, and abundant precipitation, foggy conditions are common, especially during the

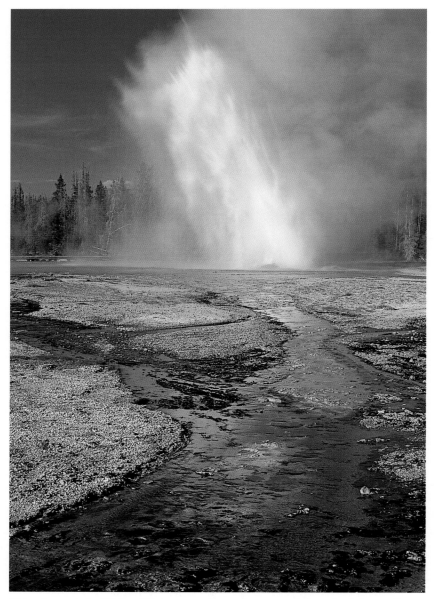

This viewpoint of Daisy Geyser was chosen because of the colorful runoff stream leading up to the geyser. The focus was set at the hyperfocal distance to render both near and far objects in sharp focus. A polarizing filter darkened the sky and made all the colors richer, and an enhancing filter emphasized the reds in the runoff stream. *Minolta 35–70mm lens, polarizing and enhancing filters, Fuji Velvia film.*

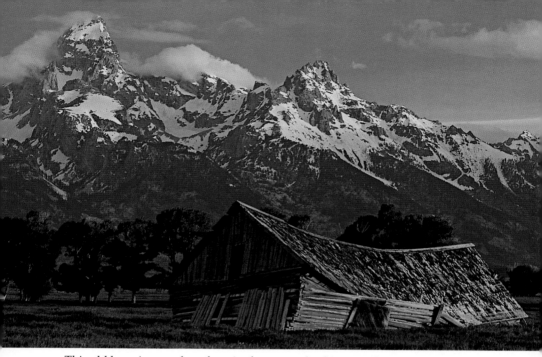

This old barn is one of my favorite foreground subjects in the Tetons. At dawn in the springtime, sidelighting gives the barn rich color and good texture. The clouds in the sky add interest and mood to the picture. *Minolta 70–210mm lens, polarizing and enhancing filters, Fuji Velvia film.*

early-morning hours, and you'll have opportunities to photograph trees and animals in the fog, the sun rising through the mist, frosty leaves, and dewy spiderwebs.

The Teton Range is perhaps the most spectacular mountain range in the continental United States, rising abruptly 7,000 feet above the valley floor. The Tetons are young mountains by geologic standards and are still being carved by rushing mountain streams and glaciers. A necklace of blue lakes at their base provides a beautiful foreground for the peaks. Fog is also common along the lakes and rivers of the Tetons in the early-morning hours, adding drama to the landscape. Jackson Hole, the broad, flat valley below the peaks, provides an exceptional viewpoint for this alpine majesty. The Snake River, which originates in the mountains of southern Yellowstone, meanders through the valley. Picturesque barns and split-rail fences, remnants of the ranching heritage of Jackson Hole before this area became a national park, provide wonderful subject material.

One of the most famous attractions of Yellowstone and the Tetons is the abundant and accessible wildlife. Elk, moose, bison, deer, pronghorn antelope, bighorn sheep, coyotes, trumpeter swans, and a variety

of smaller animals and birds are common and easily photographed. In autumn, the mating activities of the moose, elk, bison, and pronghorn antelope are fascinating. Black bears and grizzlies are not encountered as often as they were thirty years ago, but with some luck, you may see and have an opportunity to photograph them. The recently introduced wolves are multiplying rapidly and are often seen at a distance.

The Tetons and Yellowstone both exhibit an abundance and variety of wildflowers. Fields of the yellow, sunflower-shaped balsamroot add color to the Tetons in early June. Later in the season, the sagebrush flats are covered with lupine, Indian paintbrush, and scarlet gilia. In the high mountain meadows, glacier lilies, pink monkeyflowers, and Indian paintbrush are prolific. These attractive flowers can be photographed either as close-ups or with the Tetons in the background. In Yellowstone, the warm ground and marshes in the geyser basins allow fringed gentian, yellow monkeyflower, and elephantella to flourish.

Autumn brings a burst of color to northwest Wyoming. The large numbers of golden aspen and narrow-leafed cottonwoods found in Jackson Hole enhance the mountain landscape and can produce outstanding images. The brilliantly colored underbrush in both the Tetons and Yellowstone provides wonderful close-up material.

In winter, deep snow and bitterly cold temperatures, clouds, and fog are common in Yellowstone and the Tetons. But when the clouds break, the views of the peaks, geysers, winter patterns, trees, and streams are breathtaking. In winter, many park roads are closed to automobiles, but most of these areas can be reached by snowcoach, snowmobile, or on cross-country skis. The wild animals are hard-pressed to find enough food to survive the winter but are relatively easy to observe and photograph.

This combination of varied and outstanding nature subject material will make your photographic trip to Yellowstone and the Tetons extremely rewarding and give you the desire and determination to return again and again. I've tried to offer as many suggestions as I could about the specifics of taking great pictures in Yellowstone and the Tetons—where and when to go, what to look for, what vantage points work best—so you can get the most out of your visit to the parks. But when you're there, if time allows, I encourage you to slow down, look around, and discover your own views and vantage points. I hope the information I've presented will help make your photos of this beautiful region better.

ONE

Preparation and Photographic Ethics

PREPARATION
Your photographic trip to Yellowstone and the Tetons will be much easier and more productive if you're prepared. Learning about the history, botany, geology, and zoology of the parks will give you a greater appreciation and understanding of your subjects. (See Resources and References.)

Physical conditioning is also important. Most of the destinations described in this book can be reached by anyone in reasonably good health. Walking several miles a day, three days a week keeps me in condition to do the walking and short hikes that photography in Yellowstone and the Tetons requires. You may wish to check with your physician before starting a physical conditioning program.

CLOTHING AND OTHER PERSONAL ITEMS
Yellowstone and the Tetons are both high-mountain terrains where weather can change quickly and may be severe. From late May to late September, when most photographers visit the park, daytime temperatures can range from 40 to 90 degrees F. In Yellowstone, you may encounter freezing temperatures overnight at any time of year, even in midsummer. Rain is common, especially in May and early June, and afternoon thunderstorms may occur throughout the summer months. Some are severe and can be accompanied by lightning and strong winds. Even as late as May or June, and as early as September, snow may fall on the high plateaus in Yellowstone, although it usually melts quickly.

Daytime temperatures in summer are usually pleasant and often very warm. The sun may be intense due to the low humidity and high

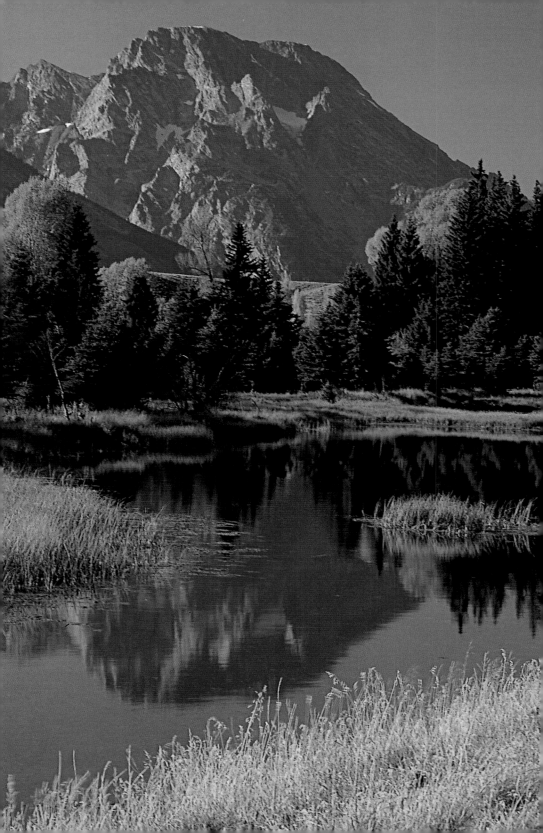

elevations, and sunscreen and a hat with a brim will help prevent sunburn. Insects, especially mosquitoes, can be a problem at this time of year, so carry insect repellent.

Even if you do not perspire as much in Yellowstone and the Tetons because of the low humidity, your body still loses a lot of moisture. Drink large amounts of water to avoid heatstroke or heat exhaustion. When hiking away from your car, take along a water bottle or canteen. In Yellowstone and the Tetons, the tap water is very pure, since it is close to the source. Don't drink out of a stream regardless of how clean it appears, however, as the risk of *Giardia* is always present.

Layered clothing is the best way to cope with the large swings in temperature that may occur during the day. It's easy to stay comfortable by adding or subtracting layers, such as sweaters, sweatshirts, or light jackets. A windbreaker is helpful, and you should carry a water-repellent jacket to protect you from sudden showers and the possibility of hypothermia. You may need a knit cap and light gloves early in the morning.

Comfortable, well-broken-in hiking boots are essential. Boots should be high enough to provide ankle support and have a lug sole for secure footing on rocks and trails. Consider wearing two pairs of socks—a thin inner pair and a heavier outer pair—for comfort. Take along a pair of extra shoes or sneakers in case your hiking boots get wet.

If you plan to visit Yellowstone or the Tetons in the winter, be prepared for severe conditions. Daytime temperatures usually range from 0 to 40 degrees F, and nighttime temperatures can drop to –20 degrees F or lower. Strong Pacific storms can drop more than a foot of snow.

A heavy parka, heavy sweater, long underwear, insulated pants, insulated boots, heavy gloves, and wool hat should be on your winter clothing list. Sunscreen is also important in the winter, because the reflection of light from the snow can cause sunburn. Sunglasses, to protect your eyes from the glare off the snow, are also a good idea.

A beaver dam near Schwabacher Landing on the Snake River serves as a reflecting pool for Mount Moran. This photograph was taken in the afternoon, as morning light in the autumn is too flat for good shadow detail and polarization. The near bank of the stream provides a strong diagonal line, gives a feeling of depth, and adds color. *Minolta 70–210mm lens, polarizing and enhancing filters, Fuji Velvia film.*

EQUIPMENT

Your specific interests, the time of year, and your budget will determine what photographic equipment you'll want to take along. You'll need different types of equipment for photographing landscapes, close-ups, and wildlife.

Camera. A good 35mm single-lens reflex camera will give you more versatility and better quality than a simple point-and-shoot camera. Canon, Minolta, Nikon, Pentax, and several other manufacturers all make equally high-quality cameras. If your only interests are landscapes or flowers, a manual-focus camera and lenses are suitable. If you also plan to photograph wildlife, an autofocus camera and lenses will be a distinct advantage.

It's good to take an extra camera body along on photographic trips. This allows you to keep fast film for wildlife in one body and slow film for landscapes in another body. Or if you want to shoot both negatives and slides of the same subject, an extra body allows you to do this. Also, if you drop and break one body, you'll have the other as a backup.

A larger camera that uses 120 or 220 film in 645, 2¼ square, or 6x7 format can also be used for landscape or close-up work. These formats give larger images, which are useful for making large prints, but they are typically more expensive, heavier, and bulkier than 35mm equipment, and they are not as versatile.

You should have a good working knowledge of your camera's functions and know how to bracket exposures by half stops (or one-third stops, if you are a Nikon user), how your metering system works, how filters affect exposure, and how to control depth of field. Before heading out to your photographic destination, determine what ISO is correct for your camera and film by shooting a test roll at different ISOs. It's a good idea to practice with your cameras, lenses, and filters at home so that you'll be able to react quickly and precisely when photographing in the field.

Lenses for Landscapes. On a 35mm camera, you will need a range of lenses for photographing landscapes, from 24mm on the wide-angle end to 200mm or even 300mm on the telephoto end. Zoom lenses are more versatile and cost-effective than an arsenal of fixed-focal-length lenses.

If you can afford the lenses made by the manufacturer of your camera, they will give more consistent color rendition than those of other brands. However, the quality of lenses manufactured by Tokina,

Tamron, Sigma, and Vivitar is improving, and they offer good value. Apochromatic glass has better sharpness and color rendition than normal glass. It's a little more expensive, but the greater quality is worth the extra money.

Equipment for Close-ups. Close-ups of many subjects, such as flowers, autumn leaves, dew-covered grass, spiderwebs, butterflies, and insects, make powerful images. However, most lenses used for landscape or wildlife photography do not focus closely enough to allow the magnification that full-frame images of these small subjects demand.

A number of good solutions are available. The cheapest is to purchase a set of close-up lenses. These lenses look like filters and usually come in sets of three that can be used either separately or in combination to achieve the proper magnification. They are relatively inexpensive and can be used on one of your existing lenses.

Extension tubes or bellows are accessories that are inserted

This frozen spiderweb, taken in a foggy meadow early in the morning, is a good example of the quality close-up material that can be found at any time in Yellowstone. My brother threw a shadow behind the web so that it would stand out better from the background. *Minolta 70–210mm lens, no filters, Kodachrome 64 film.*

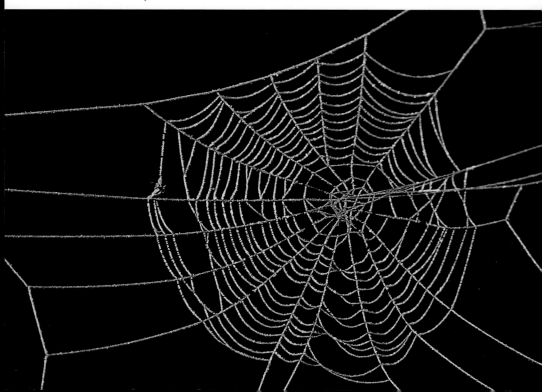

between the camera and lens to allow closer focusing. Extension tubes usually come in sets of three that can be used separately or together. Bellows can be thought of as variable extension tubes. Extension tubes and bellows do not add any glass over the primary lens and thus may yield marginally sharper pictures than close-up lenses, but both are more expensive and bulkier.

Macro lenses are simply lenses that focus much more closely than ordinary lenses. They yield high-quality images and are more convenient to use than the other options, although they are considerably more expensive.

Whichever option you choose, I recommend that the lens used for close-ups be at least 100mm in focal length. This allows you to set up farther from your subject and minimize the background area, helping to eliminate potentially distracting elements.

Equipment for Wildlife. To photograph the wildlife of Yellowstone and the Tetons, a telephoto lens gives you two advantages: It enables you to stay farther away from your subject, putting you in less danger of being attacked by potentially dangerous animals, and it allows you to photograph more wary species, such as pronghorn antelope, coyotes, and birds, without frightening or disturbing them.

For photographing most wildlife, I prefer a lens that is at least 400mm in length. A long zoom lens is better than a fixed-focal-length lens or lenses because it allows you the flexibility to quickly adjust your focal length if an animal changes its position or distance from the camera or interacts with another animal. Trying to change your lens or camera position when the action is hot usually results in frustration and missed opportunities. For sharp pictures, it's best to use a tripod with a long telephoto lens.

A good long zoom lens doesn't have to be expensive. For $400 to $500, you can get a 200–400mm Tamron zoom, an 80–400mm Tokina zoom, or a 170–500mm Sigma zoom. All have apochromatic glass. Canon has just introduced a 100–400mm lens with internal stabilization, but it is much more expensive than the other three. A zoom lens in the 75–300mm range is also useful for photographing less dangerous and less wary subjects. For more maneuverability, I frequently handhold this lens or use a monopod.

Some photographers use telextenders to increase the focal length of the primary lens. Telextenders, which magnify the image from the primary lens, are available in 1.4X and 2X. A 1.4X telextender used with a

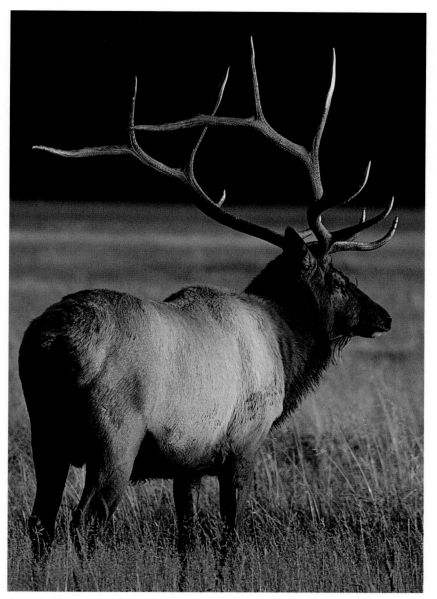

One of Yellowstone's biggest attractions is its abundant wildlife. In autumn, the courtship of the elk can be observed and photographed as the bulls round up and defend their harems. A telephoto lens is the safest and most effective way to photograph the mating activities. *Canon 150–600mm L lens, no filters, Kodachrome 200 film.*

200–400mm lens, for example, would result in a 280–560mm lens. A multiple-element telextender will optimize the quality of the resulting image.

Film. The film you use for a particular purpose is a matter of personal preference. A wide range of films exist today, and new ones are introduced every year. Each film has its own combination of speed, grain, and color rendition. Which one you choose depends on the subject material you plan to photograph and the way you, as an individual, see color.

For landscapes and close-ups, I recommend a relatively slow film, ISO 50 to 100, for either slides or negatives. These slow films have superior sharpness and very fine grain. Many fine films meet these requirements. For slides, my choice is Fuji Velvia (ISO 50). It has extremely good sharpness, fine grain, and enhanced color saturation. Its rich blacks give Velvia very good apparent contrast.

If more film speed is required for a subject where freezing motion is desired, such as a geyser eruption, I recommend Fuji Sensia 100 (ISO 100). It still has the fine grain needed for good landscapes, although the color saturation is less pronounced than with Velvia.

For negatives of landscapes, choose a film that gives good color saturation and contrast. Most negative films are made for people pictures, where lack of contrast is important. My choices are Agfa HDC 100 (ISO 100) and Agfa Ultra 50 (ISO 50), which give the color saturation and contrast in prints that Velvia gives in slides. Other good negative films for scenics include Fuji Super G 100 and Kodak Royal Gold 100.

For wildlife photography, you'll often need to stop action, so you'll need a faster film than for landscapes. My choice for slides in a faster film is Kodachrome 200 (ISO 200) because of its true color rendition and high contrast. It also renders whites better than any other film. Although the grain structure of ISO 200 films is not quite as good as that of ISO 50 or ISO 100 films, it is still acceptable. Although enhanced color saturation is desirable for landscapes, it makes wildlife look unnatural. Under low-light conditions, ISO 200 films can be pushed a stop to ISO 400 without losing much quality. Another solution is to shoot wildlife with Fuji Sensia 100 pushed one stop to ISO 200. This results in finer grain than with the ISO 200 films, but it costs more to process.

For photographing wildlife with color negative film, I recommend Fuji Super G 400 (ISO 400) or Kodak Royal Gold 400 (ISO 400). Both have much finer grain than many other fast negative films.

My recommendations for black-and-white film are the same as for color—use a 50 to 100 ISO film for scenery and a 200 to 400 ISO film for wildlife.

If you're shooting slides of landscapes in Yellowstone or the Tetons, plan on exposing five rolls per day. Negative shooters may need only three rolls per day. This is because slide makers need to bracket exposures to assure proper density, whereas the exposure of negatives is not quite as critical. Wildlife photographers may need seven to ten rolls of film per day, since many more shots of wildlife are needed to achieve good results. Although film is available in park stores and photo shops in nearby towns, prices are high. It's better to bring a few more rolls than you need than to run out of film at a critical time.

Tripod. It's best to use a sturdy tripod for most scenic photography. Having your camera on a tripod allows you to be more careful and thoughtful with your composition. Slow shutter speeds are often necessary for landscape photographs, for a number of reasons. Relatively slow films (ISO 50 to 100) are normally used for scenic photographs; the requirements for depth of field may necessitate small apertures with correspondingly slow shutter speeds. Polarizing or enhancing filters further reduce the amount of light that strikes the film, and many landscape photos are taken during the low-light conditions near sunrise and sunset.

A tripod is also useful for close-ups. Great depth of field may be needed to render the entire subject sharp, which usually means a slow shutter speed. And at high magnifications, it's especially important to frame precisely to exclude any distracting elements.

Even with the higher-speed film used for wildlife, a 400 to 500mm long lens requires a sturdy tripod to get sharp photographs. With a shorter lens, such as a 75–300mm zoom, you might be able to get away with using a monopod or even handholding under good lighting conditions, but many animals and birds are most active during the low-light conditions near sunrise and sunset.

Filters. Several filters are useful for color landscape photography. A polarizing filter has the widest application. When oriented at right angles to the sun, it eliminates glare and reflections from nonmetallic surfaces. It also makes skies darker, colors more saturated, and rainbows more vivid.

An enhancing filter can be used along with the polarizing filter. This filter enhances reds, oranges, browns, and purples, making it ideal for autumn foliage, geyser runoff streams, sunrises, and sunsets.

A split neutral-density filter evens out the contrast so that both the bright and the dark parts of a scene can be exposed properly. This is important when the sun is striking one part of a scene directly and another portion, where detail is desired, is still in shadow. This filter is also useful with photographs that involve reflections, because the reflection is usually a stop or two darker than the original scene. You may not need this filter in Yellowstone, but you may find it helpful in the Tetons when photographing landscapes with reflections.

For color photography, an 81A filter may also be useful. This filter is slightly amber and is used to remove the slight bluishness from snow scenes and to make autumn foliage a little more colorful.

For black-and-white photography in Yellowstone and the Tetons, an orange or red filter will darken the sky, causing the mountain peaks and geysers to stand out better from the background.

Miscellaneous Equipment. Don't take a lot of doodads along on a serious photography expedition. Remember that you're going to have to lug all this stuff around. However, there are some useful items that are worth the extra weight. Always take extra batteries for your camera; I always carry at least two spares. I also carry a small set of flat-head and Phillips head jeweler's screwdrivers. Another handy item is a film retriever, in case you wind the film leader back inside the cassette when changing film in midroll. A double-bubble level that attaches to the camera's hot shoe allows you to level your camera for either horizontal or vertical pictures. A cable release will help keep camera shake to a minimum when exposing your pictures. Another useful item is a soft brush to remove dust from your lenses and filters. You may also want to carry a plastic card that contains hyperfocal distance information. This is important for landscape work. The chart will tell you what distance to set on your lens, with a given focal length and aperture, to obtain maximum depth of field with infinity as the far distance.

Carrying Your Photo Gear. Although you can take some photographs in Yellowstone and the Tetons from locations close to your car, you'll often have to walk a short distance from the road. To carry your equipment, you'll need a camera bag, camera backpack, or photographer's vest. Which one you should buy is a matter of personal preference.

Camera bags will hold and protect all your equipment but must be carried either in your hand or on a strap around your neck. Though this is okay for short distances, carrying a camera bag is tiring on longer

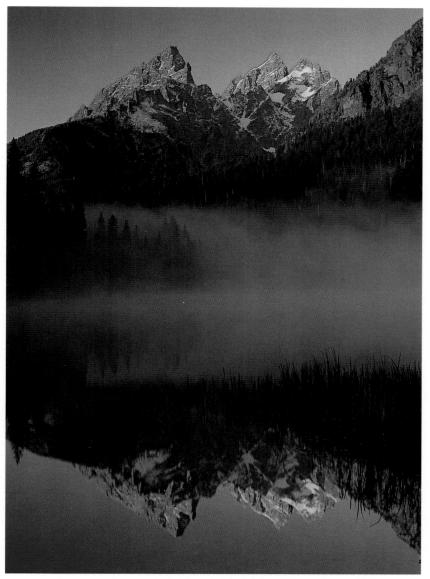

Because of the direction of light, autumn is the best time of year to photograph this appealing scene near the southern end of String Lake. A split neutral-density filter balanced the exposure between the sunlit peaks at the top of the photograph and the reflection in the water below. The reeds in the foreground give a feeling of depth to the picture. *Minolta 35–70mm lens, polarizing, enhancing, and split neutral-density filters, Fuji Velvia film.*

walks. Here a camera backpack is much more comfortable. Depending on its size, a backpack may also have room for water bottles, jackets, and food. A photographer's vest gives you quick and easy access to your extra lenses, filters, film, and other items, but it has a limited capacity, and the weight of your equipment is carried on the front of your body, which may be hard on your back.

PHOTOGRAPHIC ETHICS

When visiting Yellowstone, the Tetons, or any other natural area, you have a responsibility to not adversely affect its ecology. This includes abiding by all park rules. Many things are obvious: Don't pick flowers; don't harass wildlife; don't remove rocks, artifacts, or plants from the area; and don't throw coins or other articles into the hot springs or geysers.

You have to decide for yourself what is appropriate when photographing nature. Some people believe that if an animal even looks up when you approach, you are harassing it. I don't agree. However, I would never disturb a bird on a nest or a fawn hidden in the grass. Some photographers think it's wrong to remove distractions such as blades of grass, small rocks, or pinecones from behind a subject such as a flower. I don't agree with that view, either. But you should always leave an area in the same condition as you found it. Millions of people visit this area every year, and carelessness may cause permanent damage. You came to Yellowstone and the Tetons to photograph their beauty; be sure that you do nothing to lessen that beauty.

Yellowstone National Park

WHAT TO EXPECT IN THE PARK

Between May 1 and October 31, most of the park roads in Yellowstone National Park are open to motor vehicles. The loop road in Yellowstone is shaped somewhat like a figure eight and comprises 154 miles of roadway. Some parts are in good condition; others may be badly in need of repair. This loop road will take you to, or within easy walking distance of, almost all of the park's most photogenic features.

Five entrance roads connect with the main loop road—one on the west from West Yellowstone, Montana; one on the north from Gardiner, Montana; one on the northeast from Billings, Montana; one on the east from Cody, Wyoming; and one on the south from the Tetons and Jackson, Wyoming. All except the road from the northeast, over the Beartooth Mountains, are open from about May 1 to October 31. The Beartooth highway is usually open from about May 30 to October 16. The road from Gardiner, Montana, to Mammoth and then on to Tower Junction and Cooke City, Montana, at the northeast entrance, is open all year. Entrances to the park are open twenty-four hours a day during the summer season, although the entrance stations may not be staffed at night.

With many of the park's roads in poor condition, you may run into road construction during the summer months. Roads under construction are often closed during certain hours each day and may be closed completely toward the end of the season. Delays of half an hour or more can be expected in construction zones, even during the hours that the road is officially open. To find out which roads are going to be affected during the time you plan to spend in Yellowstone, or for any other information, write to the Superintendent, Yellowstone National Park, WY 82190, or telephone (307) 344-7381.

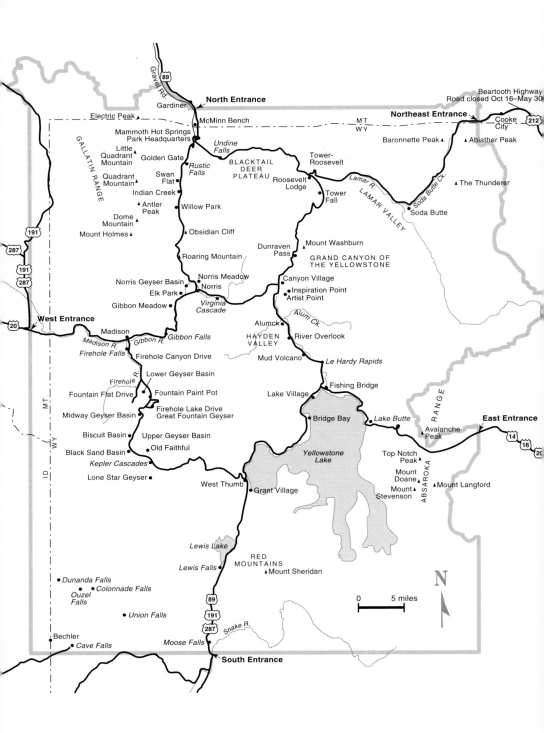

Facilities in the Park. Lodging in the park is available during the summer months at Old Faithful, Mammoth, Roosevelt Lodge (Tower Junction), Canyon Village, Lake Village, and Grant Village. Many of these facilities are antiquated and spartan, although some have been recently renovated. Reservations are sometimes difficult to obtain, and the costs are as high as the much nicer motels outside the park. Nevertheless, many of these facilities are historic, and if you enjoy staying at vintage hotels or simply prefer to have accommodations inside the park boundaries, you may want to stay at one of them. Most of them close for the winter by late September or early October, but the Snow Lodge at Old Faithful and the Hotel at Mammoth are open from late December to early March.

During the summer months, a variety of food service is available within the park. These establishments range from snack bars to cafeterias and even formal dining rooms. The quality of food is generally good and the prices are reasonable for the area. Most of these eating places are closed by the end of September.

Eleven campgrounds are located throughout park. Camping spaces are available for a modest fee on a first-come, first-served basis. There are no trailer hookups.

General stores with groceries, souvenirs, clothing, and film are open during the summer. Gasoline is available at Mammoth, Canyon, Old Faithful, Tower Junction, Fishing Bridge, and Grant Village, sometimes at a lower price than in the surrounding towns. All of the stores and gas stations in the park close in early October.

Facilities in the Surrounding Towns. There are modern motels to suit every budget in West Yellowstone, Gardiner, and Cooke City, Montana; and Cody and Flagg Ranch, Wyoming. West Yellowstone and Gardiner are the closest to the most photogenic parts of the park. During the summer months, room rates are higher and reservations are mandatory. In May and September, there are fewer visitors and room rates are more reasonable, but reservations are still recommended.

Camping facilities, most with trailer hookups, are available in all of the towns surrounding Yellowstone. Some National Forest Service campgrounds, without trailer hookups, are located outside most of the park entrances.

The towns surrounding Yellowstone offer a wide variety of eating establishments, most of which are open year-round, and plenty of gas stations.

Film and camera batteries are available at photo shops in West Yellowstone, Cody, and Flagg Ranch. The nearest store to Yellowstone that carries single-lens reflex cameras, lenses, tripods, and other photo supplies is in Bozeman, Montana, about 80 miles from Gardiner.

Arriving in Yellowstone. Your first stop will probably be at one of the entrance stations, where you'll have to pay an entrance fee. At the time of this writing, a one-week pass good for both Yellowstone and the Tetons cost $20; a Golden Eagle Pass, which admits you to all national parks, monuments, and wildlife refuges for one year, cost $50; and a Golden Age Pass, which admits persons sixty-two years of age or older to all national parklands for the rest of their lives, cost $10.

You should stop at a visitor center at your first opportunity. Here, you can obtain current information about wildlife and other unique photographic opportunities in the park—for instance, a geyser that is erupting that hasn't been active for years. There's also a good selection of maps and books about various aspects of the park. Visitor centers are located at Mammoth Hot Springs (park headquarters), Old Faithful, Canyon Village, Grant Village, and Fishing Bridge.

Park rules are the same for all visitors to Yellowstone. *The most important rules in Yellowstone are that you must stay at least 25 yards from all wildlife, including birds and waterfowl, and you must not approach within 100 yards of bears.* Another important rule is not to leave the boardwalk in a geyser basin. In some thermal areas, the crust is very thin, and you could fall through and be scalded or even killed. Also, walking on the thermal features leaves footprints, damaging the formations.

You may not be able to achieve much of a wilderness feeling in the park during the main tourist season. The crowds are worst from the last week of June through mid-September. I try to photograph in the park in mid-June, late September, and during the winter, when visitation is lower. The park roads may become clogged during the busier times of year because of the heavy volume of traffic combined with a road system that was in large part designed and constructed seventy-five years ago. You can avoid traffic congestion by driving early in the morning or late in the evening.

Upon arriving in Yellowstone, many people are shocked and saddened by the devastation caused by the forest fires of 1988. In many places along the park roads, the once verdant forests are now wastelands of burned trees and deadfalls. At least 35 percent of the trees in Yellowstone were either partly or completely burned. At this writing,

some ten years after the fires, the new-growth trees are only about 3 feet tall, and it will take another generation to erase the effects of this tragedy. Despite the devastation that can be observed from many parts of the loop road, the immediate areas around most of the park's main features were not affected, and wonderful photographs are still possible.

PHOTOGRAPHING THERMAL FEATURES

Thermal features are the most well-known and interesting photographic subjects in Yellowstone. They exhibit both power and beauty but also present some unique challenges. Photographs of geysers and hot springs are most successful when the sky is clear or has only a few puffy clouds. If the sky is overcast, the plume of water and steam from a geyser does not stand out from the background, and the whole picture looks drab. A blue sky causes hot pools, which reflect the color of the sky, to be a beautiful shade of blue, but if the sky is gray, hot pools are unattractive.

When planning to photograph a geyser, hot pool, or mud pot, always check the direction of the wind. Ideally, the wind should be at your back so that the steam from the thermal feature blows away from you. This allows you to see and photograph the feature much better. With geysers, the column of water, which is the most interesting part of the eruption, can be seen much better when the wind is blowing the steam away from you. If the wind is from the side, leave room to the side of the geyser for the steam when composing your photograph.

More steam develops when the air is cold. Many of the thermal features are difficult to photograph early in the morning, even in summer. Late morning, afternoon, and evening usually present better opportunities. In the late autumn, winter, and spring, too much steam can make photographing hot pools and mud pots difficult or impossible.

For successful geyser photography, you need both patience and luck. Park personnel record the timing and characteristics of the eruptions of each major geyser in the park and then try to predict the time of the next eruption. Some geysers erupt at fairly regular intervals, others can be predicted within several hours, but most are totally unpredictable. I've waited for three or four hours for a geyser to erupt. For geysers with erratic eruptions, it's helpful to be able to recognize the signs that an eruption is imminent, such as water overflowing the crater or excessive bubbling and steam. Or you may just be lucky and have an unpredictable geyser go off when you are close by.

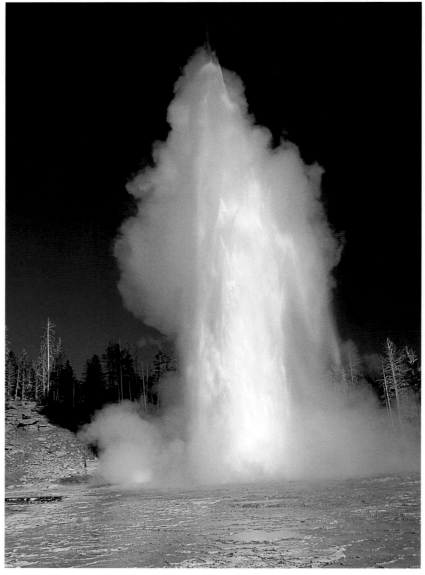

Grand Geyser erupts higher than any of the other predictable geysers in the park. The camera position was carefully chosen to include the colorful runoff stream at the base, stay upwind from the geyser, and be at right angles to the sun. A very wide-angle lens was needed to capture both the entire column of water and the runoff stream. *Minolta 24–35mm lens, polarizing and enhancing filters, Fuji Velvia film.*

The time between eruptions depends on many variables, including the supply of groundwater, the proximity of the heat source (magma), the configuration and size of the geyser's plumbing system, the surface temperature, the length of time of the previous eruption, and the volume of water expelled. Minor earthquakes, which are common in seismically active areas like Yellowstone, may change the characteristics of a geyser either temporarily or permanently. Major tremors may cause a geyser to cease erupting or to erupt vigorously after years of dormancy.

When you have an idea of the eruption time, it's best to arrive early. This will give you time to analyze the composition, lighting possibilities, and wind direction and choose a good vantage point. Look for lines and patterns such as runoff streams that lead to the thermal feature, and include them in your composition. Many runoff streams are brightly colored from the bacteria and algae growing in the warm water. These streams will add color and depth, creating a more interesting picture than just a close-up of the thermal feature. Estimate the height of the eruption from published literature, and try to choose a lens that will include the column of water, steam, and any attractive foreground elements. If you use a zoom lens, you can make rapid changes in your composition if necessary when the geyser erupts.

Sidelighting provides the best illumination for most photos in the geyser basins, but backlighting can also be effective, especially when a geyser erupts near sunrise or sunset. For backlit shots, I place the sun behind the column of water and steam. This prevents sun flare and brings out the texture of the water.

Obtaining the correct exposure in a geyser basin can be a problem. The camera's exposure meter is affected by the light-colored rock around most of the thermal features, as well as the brightness of the column of water and steam, causing your photographs to be underexposed unless you compensate for this. For most thermal features, this problem may be solved by giving the picture from a half to one stop more exposure than your meter indicates. In addition, it's good to bracket exposures in half-stop intervals (one-third-stop for Nikon).

Take extra care in the geyser basins to protect your camera equipment. Fog or steam from the thermal features will cause no harm, but the water droplets from a geyser's eruption contain a small amount of dissolved silica. If this geyser water falls on the glass portion of a lens or filter, the silica may adhere to the surface and cause permanent

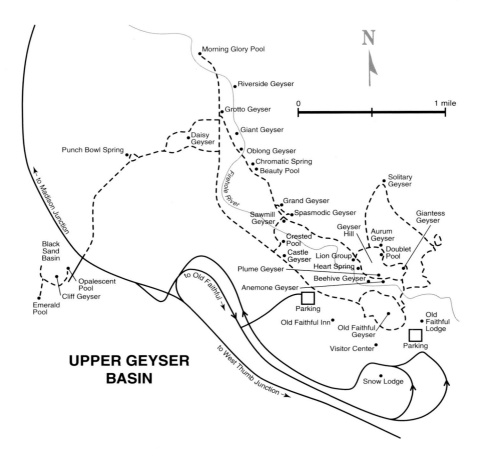

Morning Glory Pool

Riverside Geyser

Grotto Geyser

Giant Geyser

Daisy Geyser

Punch Bowl Spring

Oblong Geyser
Chromatic Spring
Beauty Pool

N

0 1 mile

Solitary Geyser

Grand Geyser

Spasmodic Geyser

Sawmill Geyser

Giantess Geyser

Geyser Hill

Aurum Geyser

Crested Pool

Doublet Pool

Castle Geyser

Lion Group

Plume Geyser

Heart Spring

Beehive Geyser

Anemone Geyser

Black Sand Basin

Opalescent Pool

Cliff Geyser

Emerald Pool

to Madison Junction

Firehole River

to Old Faithful

to West Thumb Junction →

Parking

Old Faithful Inn

Old Faithful Geyser

Old Faithful Lodge

Visitor Center

Parking

Snow Lodge

UPPER GEYSER BASIN

damage. This is another excellent reason to stay upwind from a geyser's eruption, since the wind may carry these droplets a considerable distance.

Upper Geyser Basin. Upper Geyser Basin contains most of the largest and most predictable geysers in the park, including Old Faithful. It also features a number of attractive and interesting smaller geysers and hot pools. Large parking areas are located adjacent to Old Faithful. Your first stop should be at the visitor center, where the expected times of eruption of the major geysers are posted. This information will allow you to plan so that you can witness and photograph as many geysers as possible. Also buy the brochure covering Old Faith-

ful, Upper Geyser, Black Sand, and Biscuit Basins. Other brochures that you will eventually need are on Norris Geyser Basin, West Thumb Geyser Basin, Fountain Paint Pot and Firehole Lake Drive, Mud Volcano, Mammoth Hot Springs, and the Grand Canyon of the Yellowstone.

Old Faithful is not the most regular or the tallest geyser in Yellowstone, but it erupts more often than any of the other big geysers and is the most photographed geyser in the world. The average interval between eruptions is seventy-six minutes, and it erupts for one and a half to five minutes, reaching a height of about 150 feet. Your challenge is to find a way to photograph Old Faithful in a way that captures its beauty and power.

Most people view and photograph Old Faithful from the south side of the geyser near the visitor center, but I find that more interesting compositions may be obtained from other angles. Since a boardwalk goes completely around Old Faithful, you have many choices for your camera position, depending on the wind direction, time of day, and direction of light.

One of my favorite angles of Old Faithful is from the east side, using a small pine tree for framing. This is also the position from which to photograph Old Faithful with the setting sun behind the column of water in summer or at sunrise in winter.

Another good camera position is on the north side of the geyser. From this angle, several well-defined runoff streams, which are lined by golden grass in the autumn, provide lead-in lines to the geyser. Late afternoon is an excellent time to photograph Old Faithful from this location.

The walk around Geyser Hill, just north of Old Faithful across the Firehole River, is one of the most interesting in the Upper Geyser Basin. It contains several noteworthy geysers and hot pools, all good photographic subjects. The total distance around the loop from the visitor center is 1.3 miles.

The most easily photographed geyser on the Geyser Hill Loop is Plume Geyser, which erupts every twenty to thirty minutes to heights of up to 25 feet. Its eruptions are characterized by three to five separate bursts. The boardwalk skirts the south side of Plume Geyser, and pictures are possible in the morning and afternoon. A good camera position uses color in the runoff stream but doesn't include nearby portions of the boardwalk or any people that might be on them. You may need a wide-angle lens.

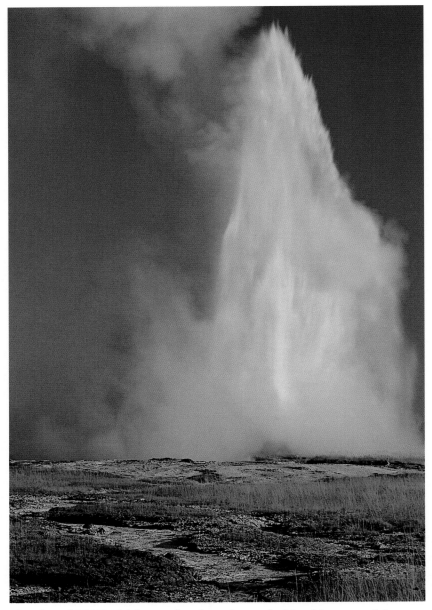

This shot of Old Faithful was taken from the north side of the geyser late one autumn afternoon. The camera position was chosen to accentuate the golden grass and the runoff stream leading up to the geyser. The column of water was placed to the right of center, since the steam was being carried to the left. *Minolta 70–210mm lens, polarizing and enhancing filters, Fuji Velvia film.*

Anemone Geyser, near Plume Geyser, erupts from a colorful pool. It reaches a height of about 10 feet at intervals of seven to ten minutes. Afternoon light and a wide-angle lens are best.

Beehive Geyser is a major geyser that erupts 130 to 180 feet high from a narrow cone. Although the Geyser Hill Loop passes very close to the cone, one of the best angles from which to photograph Beehive is from the south side of the Firehole River on the northwest portion of the trail encircling Old Faithful, using a moderate telephoto lens. Other good spots are directly east and west of Beehive Geyser along the Geyser Hill boardwalk. Which spot is best depends on the wind direction and time of day. Beehive generally erupts two times a day but is unpredictable. Water overflowing the cone usually indicates that an eruption is imminent.

Heart Spring is a beautiful blue pool that lies directly in front of the Lion Geyser Group. The Lion Geysers are unpredictable but are usually active at some time each day. Even when the geysers are not erupting, Heart Spring, with the steaming Lion Geyser cones in the background, makes a fine picture. The deep blue waters of Doublet Pool are surrounded by an ornate series of geyserite ledges. The overall pool is very attractive, and the beautiful geyserite patterns make interesting close-ups. Heart Spring and Doublet Pool are best photographed in late morning to early afternoon.

Other features along the Geyser Hill Loop that you may want to photograph are Ear Spring, Aurum Geyser, and Giantess Geyser. Ear Spring is difficult to photograph creatively, because you are confined to the boardwalk, which does not provide the best camera positions. Aurum Geyser erupts to a height of several feet on an irregular basis. The geyserite pattern and colors around the geyser are very attractive. Giantess Geyser has active phases only two to six times a year, so you would be fortunate indeed to photograph it. When it does become active, Giantess reaches heights of 100 to 200 feet and erupts twice hourly for twelve to forty-three hours.

A 1-mile round-trip trail leads from the northwest portion of the Geyser Hill Loop to Solitary Geyser, an attractive small geyser that erupts to a few feet in height at intervals of about ten minutes. Several beautiful runoff streams provide for interesting compositions and add color. Although hiking to Solitary Geyser involves some elevation gain, it's worth the effort.

North and west of Old Faithful and the Geyser Hill Loop are a number of other photogenic geysers and hot springs, including Castle

Geyser, Grand Geyser, Riverside Geyser, Daisy Geyser, and Morning Glory Pool. A round-trip hike including all of these features is about 4 miles on paved trails or boardwalks, most of which are level. Since these features require a little more effort to reach, you will encounter far fewer people than in the Old Faithful area, even in peak season. To minimize the distance you'll need to walk, park your car on the west side of the Old Faithful Inn near the Hamilton Store and Service Station. If you have a bicycle, you can pedal to many of these features. For a 2-mile round-trip hike, you can visit just Castle and Grand Geysers, and then return to your vehicle.

Castle Geyser is one of the oldest geysers in the park, with a 25-foot-high geyserite cone that has built up over the years. It erupts every ten to twelve hours to a height of 90 feet. During an eruption, a twenty-minute-long water phase is followed by a thirty- to forty-minute steam phase. There are colorful runoff streams on the west side of the geyser that are best photographed in the afternoon. During a late-afternoon eruption, you may find a rainbow to include in your photograph. A properly oriented polarizing filter will enhance the intensity of the rainbow.

At Castle Geyser, a boardwalk to the right leads across the Firehole River to Grand Geyser. Just north of Castle Geyser is Crested Pool, a beautiful deep blue pool surrounded by intricate geyserite formations. A wide-angle shot including the valley of the Firehole River in the background is a wonderful view of Crested Pool. Just north of the Firehole River is South Scalloped Springs, a good photographic subject in late morning. Near Grand Geyser are two small, active geysers named Sawmill Geyser and Spasmodic Geyser. Afternoon is best for pictures of both of these features. A wide-angle lens and a fast shutter speed will freeze the water droplets during eruptions.

Grand Geyser is the tallest predictable geyser in Yellowstone, erupting to a height up to 200 feet every seven to fifteen hours. A typical eruption consists of one to four separate bursts from a large pool at the base of the geyser. A boardwalk runs on the south and west sides of the geyser, and good pictures are possible from midmorning till sunset. This geyser has colorful runoff streams. You'll need a wide-angle lens to photograph Grand Geyser and its surroundings.

Photographing Grand Geyser requires a lot of patience. Predictions are usually given at a certain time plus or minus two hours. This means that the geyser may erupt within a four-hour window. Benches are provided to make the wait more comfortable. Water flowing from the pool

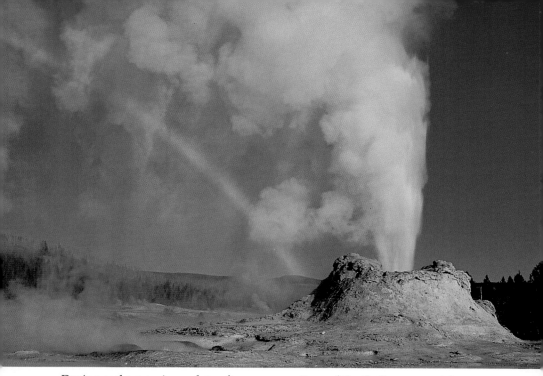

During early-morning or late-afternoon eruptions of Castle Geyser, a rainbow is usually visible. As the eruptions last almost an hour, you'll be able to find the best vantage point after an eruption starts. A polarizing filter makes the rainbow more brilliant. *Minolta 35–70mm lens, polarizing and enhancing filters, Fuji Velvia film.*

of water that contains Grand Geyser indicates that an eruption might occur. If, after this increased flow begins, a small nearby geyser erupts, the pressure in the system is relieved and Grand will not erupt on that cycle. This pattern is repeated every twenty to twenty-five minutes, until Grand Geyser finally erupts. Although the wait can be exasperating, the final eruption is usually spectacular.

Northwest along the boardwalk are two attractive hot pools: Beauty Pool and Chromatic Spring. Beauty Pool is the more spectacular of the two and has a range of colors from blue and green to yellow, orange, and red. You'll need a very wide-angle lens to include all of Beauty Pool. A polarizing filter and enhancing filter will intensify the color, but with a wide-angle lens, these extra filters may cause vignetting.

After recrossing the Firehole River, you'll encounter Oblong Geyser and Giant Geyser. The eruptions of both of these geysers are unpredictable and you have to be lucky to observe one. Giant Geyser was once one of the major geysers in the park, but minor shifts in its plumbing system in the 1950s caused it to become dormant. During the last

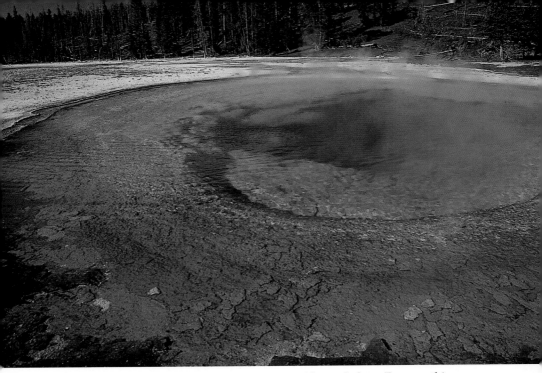

Photographing Beauty Pool requires a very wide-angle lens. Even so, this photograph, shot at 24mm, doesn't include all of the pool. Midafternoon is the best time to photograph Beauty Pool, because there is too much steam in the morning. Polarizing and enhancing filters make the colors in the pool more saturated. *Minolta 24–35mm lens, polarizing and enhancing filters, Fuji Velvia film.*

few years, it has become active again and erupts every three to ten days to a height of 180 to 250 feet. The large cone of Giant Geyser is very attractive and makes a worthwhile image even if the geyser is not erupting. Afternoon is the best time to photograph Giant Geyser or its cone.

The boardwalk rejoins the main paved trail at Grotto Geyser. The strangely shaped cone of this geyser probably makes a more interesting photograph than its eruption. The shape is thought to be the result of many eons of geyserite deposition on tree trunks that once grew here. Grotto Geyser erupts to a height of 10 feet about every eight hours. The steam from these eruptions usually hides the cone. Early-afternoon pictures are best here, because a stand of trees throws a shadow on the geyser by late afternoon.

A short distance north along the paved trail is Riverside Geyser, one of the most beautiful geysers in Yellowstone. It erupts gracefully out over the Firehole River to a height of 75 feet. Its eruptions are fairly predictable, at intervals of five and a half to six and a half hours. A rainbow is often visible in late afternoon, making this the best time to

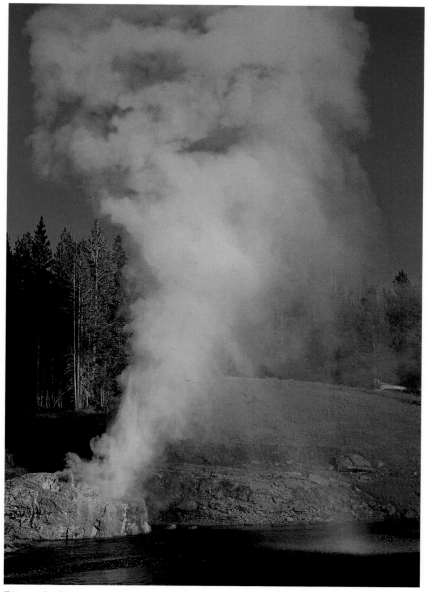

Riverside Geyser erupts at an angle out over the Firehole River. Late in the afternoon, a rainbow can usually be included in the picture. Since the eruptions last for twenty minutes, it's easy to position your camera after an eruption begins. *Minolta 35–70mm lens, polarizing and enhancing filters, Fuji Velvia film.*

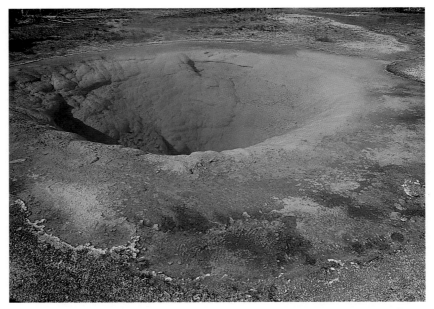

Morning Glory Pool is one of the most beautifully colored hot springs in the park. A very wide-angle lens along with polarizing and enhancing filters is needed to optimize results. The best photographs eliminate any trace of the boardwalk, which is very close to the pool. *Minolta 24–35mm lens, polarizing and enhancing filters, Fuji Velvia film.*

photograph an eruption. Eruptions of this geyser last about twenty minutes, so you'll have plenty of time to look for a rainbow once the eruption starts.

The paved trail crosses the Firehole River again and ends at Morning Glory Pool, one of the most beautiful hot springs in the park. Many years ago, Morning Glory Pool was deep blue. But as people threw coins and other debris into the pool over the years, the vent of the spring was affected, and the water cooled somewhat. This allowed yellow and orange bacteria to spread toward the center of the pool, changing the color somewhat. Nevertheless, the pool still makes a wonderful photographic subject. Midmorning to midafternoon light is best. You'll need at least a 24mm lens to include all or most of the pool.

On the way back to your car, you can take the spur trail to Daisy Geyser and Punch Bowl Spring. This trail branches off the main paved trail just south of Grotto Geyser. Daisy Geyser is very predictable and

erupts at an angle to a height of about 75 feet every 90 to 115 minutes. The southeast side provides a good vantage point for eruptions of Daisy Geyser, with a colorful runoff stream making a good lead-in line. This interesting geyser can be photographed any time of the day. Farther along the spur trail is Punch Bowl Spring, an attractive pool with an interesting scalloped edge and brilliant orange runoff streams. The lighting on Punch Bowl Spring is good throughout the day.

Black Sand Basin. Black Sand Basin, which contains several attractive springs and geysers, is about half a mile northwest of the Old Faithful interchange along the main loop road. North of the Black Sand Basin parking lot is Opalescent Pool, a colorful spring that is best photographed from midmorning to midafternoon. A number of pine trees that previously grew here have been killed and silicified by waters from Opalescent Pool, and a photograph that includes these dead trees along with the pool tells an interesting nature story.

From the parking lot, a boardwalk leads west to the bridge over Iron Spring Creek. You can photograph Cliff Geyser, a very active small geyser on the banks of the creek, from the bridge in a composition that

Mid to late morning is the best time to photograph Emerald Pool. I used a very wide-angle lens to include the colorful runoff stream at the base of the picture. *Minolta 24–35mm lens, polarizing and enhancing filters, Fuji Velvia film.*

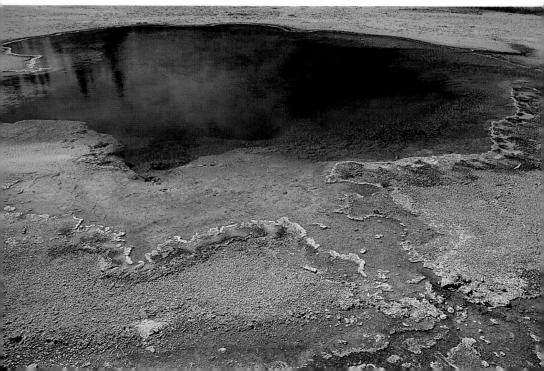

includes the stream. A moderate telephoto lens will increase the size of the geyser relative to the creek.

To the south is Emerald Pool, one of the most beautiful pools in the park. Its deep green waters and the colorful runoff stream on its north side are best photographed in midmorning or late afternoon. You'll need a very wide-angle lens (24mm) to include all of the pool and the runoff stream.

Also in the Black Sand Basin are Sunset Lake and Rainbow Pool. They are colorful, but both generate a lot of steam, and I haven't had much luck photographing them effectively.

Biscuit Basin. About 3 miles farther northwest along the main loop road is Biscuit Basin, named for the interesting geyserite knobs found around some of its hot springs. The loop trail through this small thermal area is .6 mile in length. The most interesting thermal feature in Biscuit Basin is Jewel Geyser, which erupts to a height of about 25 feet at intervals of ten to fifteen minutes. The eruption is characterized by three or four separate bursts and is best photographed from midmorning to late afternoon. From the boardwalk on the south side of Jewel Geyser, you'll need a wide-angle lens to include the entire column of water and the colorful formations at its base.

Midway Geyser Basin. The loop trail at Midway Geyser Basin, which starts at the parking lot, is about a mile in length and is well worth the effort. After crossing the Firehole River, the trail climbs the south bank of the river alongside a colorful runoff stream from the Excelsior Geyser Crater. A moderate telephoto lens will allow you to concentrate on the designs, patterns, and colors along this stream. Excelsior Geyser no longer erupts but at one time was one of the largest geysers in the park. It still emits large amounts of steam, making the crater and hot pool difficult to photograph.

Grand Prismatic Spring is one of my favorite photographic subjects in Yellowstone. The runoff streams produce a rainbow of colors that are dependent on the temperature of the runoff water. Yellow bacteria are found in the hotter waters close to the spring; orange, red, and brown bacteria grow in progressively cooler waters. The shapes and colors of these streams change and produce exciting new images each year.

In late morning, there is good sidelighting on the spring. The lighting is not as good from midday to late afternoon. Early in the morning, or if the day is cold or the wind is from the south, there may be too much steam.

Mid to late morning provides the best lighting for the runoff streams from Grand Prismatic Spring. A wind from the north will take the steam away from your camera position. This image was made with a very wide-angle lens, but telephoto shots of the colorful patterns are effective as well. *Minolta 24–35mm lens, polarizing and enhancing filters, Fuji Velvia film.*

Very wide-angle lenses (24–35mm) will allow you to capture the large patterns and the variety of colors. To focus on smaller patterns and details, I use a moderate telephoto (70–210mm) lens. Polarizing and enhancing filters will make the colors more vivid and saturated.

Another interesting shot at Grand Prismatic Spring is the reflection of the sunset on the terraces and runoff streams. The quality of this shot depends on the intensity of the color in the clouds. If the sky is clear, the color will be mediocre at best. A good vantage point is from the east side of the loop between Excelsior Geyser Crater and Grand Prismatic Spring

Firehole Lake Drive. About 2 miles to the north of Midway Geyser Basin is Firehole Lake Loop, a one-way road leading to several interesting geysers. Great Fountain Geyser erupts from a beautifully terraced pool in a series of separate bursts to a height of 100 to 200 feet. Eruptions occur every eight to twelve hours. About one hour before an eruption, water starts to overflow the crater. A wide-angle lens will capture both the eruption and the interesting terraces at the base.

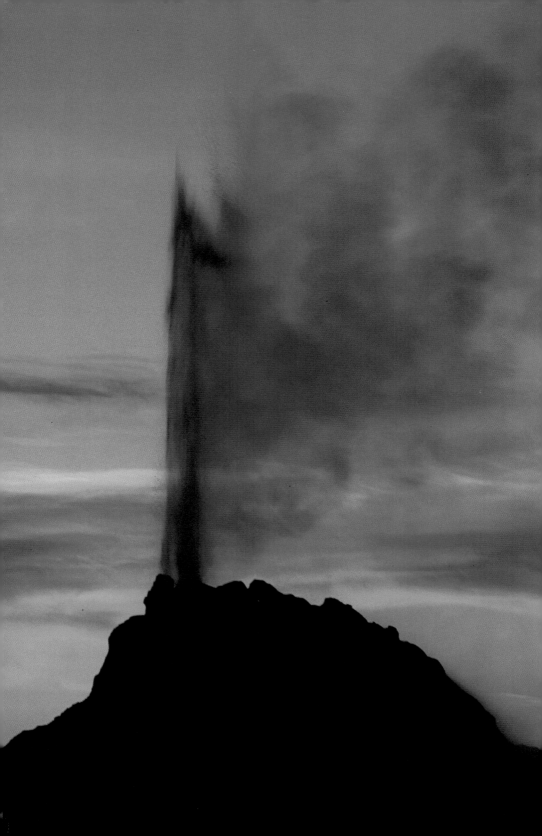

Good photographs can be taken at any time of day. When choosing the best photographic position, you'll have to consider not only the wind direction and lighting, but also how to eliminate the road, cars, and people from the composition.

Even if Great Fountain Geyser is not erupting, the terraced pool makes an attractive image. A moderate telephoto lens will capture close-up patterns, and a wide-angle lens will allow you to include the whole pool. At sunset, if there are colorful clouds in the sky, they will reflect in the pool and make an interesting picture.

Just northwest of Great Fountain Geyser on the Firehole Lake Drive is White Dome Geyser. The deposition of geyserite over many years has built up a large cone. The eruptions, which are about 30 feet high at intervals of twenty to thirty minutes, last for about two minutes and are very graceful and artistic.

Photographs of White Dome Geyser can be taken at any time of day, but my favorite time is at or near sunset. Before the sun goes down, it can be placed behind the large cone of White Dome Geyser, and an eruption will be beautifully backlit without any danger of lens flare. You may need a low camera position to achieve this composition. After the sun goes below the horizon, the cone and plume of the geyser can be silhouetted against the sky. The better the color in the sky, the better this image will be.

Just past White Dome Geyser, the road parallels a little stream called Tangled Creek. The stream has a beautiful braided pattern, with little grass-covered islands. This subject is especially appealing in autumn, when the grass on the islands is gold and contrasts with the deep blue waters. A moderate telephoto lens will allow you to concentrate on the most interesting parts of the overall pattern.

The next good photographic subject on the Firehole Lake Loop is Pink Cone Geyser. Although unpredictable, this small geyser usually erupts to a height of about 30 feet at least once a day. Eruptions are very graceful and last from thirty minutes to three hours. You may wish to include one or more of the dead white trees near Pink Cone Geyser to add compositional elements and help tell the nature story.

Firehole Lake and Steady Geyser, just beyond Pink Cone Geyser,

If the sky is colorful, sunset is a good time to take photographs of White Dome Geyser. Expose for the sky, eliminating any dark areas which you want to be in silhouette from your exposure calculations. *Minolta 35–70mm lens, enhancing filter, Fuji Velvia film.*

erupt almost constantly and are interesting to observe but generate dense steam. The Firehole Lake Drive rejoins the main road at Lower Geyser Basin and Fountain Paint Pot parking area.

Lower Geyser Basin and Fountain Paint Pots. The boardwalk through the Lower Geyser Basin and Fountain Paint Pot area leads to several interesting thermal features and is about half a mile in length. Keep to the right at the trail junction and you'll soon see Silex Spring, a beautiful blue pool surrounded by colorful bacterial mats. A wide-angle lens will allow you to include the entire pool. Afternoon is best for this shot, since you'll be pointing your camera toward the east.

The Fountain Paint Pots are the most accessible and colorful example of this type of thermal feature in Yellowstone. Mud pots differ from hot springs in that they have only a limited supply of ground-water available and do not overflow. The mud, derived from decomposition of the underlying rhyolitic rock by acids and hot water, builds up and is lobbed into the air by steam bubbles. The mud in the Fountain Paint Pots is colored shades of pink and red by iron oxides.

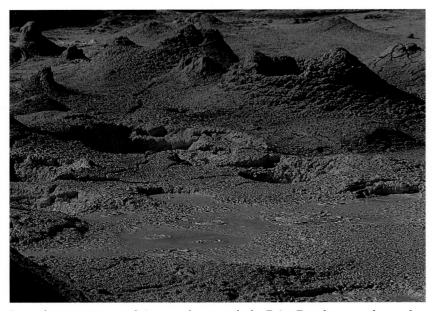

Late afternoon is a good time to photograph the Paint Pots, because the mud has more color and texture at that time. Be sure to exclude the boardwalk. A variety of shots can be tried here, including close-ups of patterns in the mud and mud plops. *Minolta 70–210mm lens, polarizing and enhancing filters, Fuji Velvia film.*

Late afternoon is a good time to photograph the paint pots, since low lighting emphasizes the texture and color of the mud. A wider view that includes the mud area as well as the strange mounds of mud around the edge makes an interesting shot. Telephoto images of the patterns and bubbles in the mud will test your compositional skills as well as your reactions. Capturing a mud plop in midair is indeed a challenge.

Proceeding around the boardwalk, you will arrive at a group of small geysers dominated by Clepsydra Geyser. This geyser erupts continuously and generates a lot of water and steam. Your best opportunity to obtain a good photograph of Clepsydra Geyser will be during the late morning on a day when the wind is from the east.

Norris Geyser Basin. Proceeding north on the main loop road, the next important thermal area is Norris Geyser Basin, the hottest and most changeable thermal area in Yellowstone. Norris doesn't have as many good photographic subjects as Upper, Midway, or Lower Geyser Basin, and the area immediately around many of Norris's thermal features is cluttered with loose rocks and dead trees. If you're short on time, I recommend skipping Norris Geyser Basin and concentrating on other, more productive parts of the park.

Two trails lead from the Norris Museum into the geyser basin. On the half-mile Porcelain Basin Loop are many small fumaroles, springs, and geysers, most of which aren't very photogenic. The most noteworthy is Whirligig Geyser, an active little spouter with a good deal of color around the opening. The 1.5-mile Back Basin Loop heads south past Emerald Spring, a beautiful deep green pool, to Steamboat Geyser, at 300 feet the world's tallest active geyser, although eruptions are irregular and rare. A little farther along the trail is Echinus Geyser, which erupts every thirty-five to seventy-five minutes to a height of 50 feet—probably the best photographic destination in Norris Geyser Basin. Afternoon is the best time to photograph this geyser.

Mammoth Hot Springs. The hot springs at Mammoth are different from the other thermal areas of Yellowstone. The subsurface rock in the other geyser basins is a silica-rich volcanic rock called rhyolite, which is only slightly soluble in hot water. The water cools as it flows away from or is ejected from the hot pool or geyser, and the silica dissolved in it is deposited as geyserite around the thermal feature. The deposition of geyserite is very slow, and hundreds or thousands of years are needed to build up a cone like the ones at Castle Geyser or White Dome Geyser.

At Mammoth Hot Springs, the subsurface rock is limestone, which is very soluble in hot water. The calcium-rich waters emerge at the surface and more quickly, geologically speaking, deposit terraces of travertine. Where active water flow exists, the formations are colored by bacteria and algae and make attractive photographic subjects. When the water flow is cut off, the bacteria and algae die, and the inactive terrace becomes a dull gray. Close-ups of the active formations reveal intricate patterns, colors, and filigree.

At Mammoth Hot Springs, older terraces are constantly drying up and new ones are being born. Twenty years ago, Minerva Terrace and Jupiter Terrace were the most active springs at Mammoth. Today, Jupiter Terrace is completely dried up and Minerva Terrace is not as active as it once was. The terraces described in this book may not be as active by the time you visit Mammoth, but if you keep the photographic ideas in mind, you can apply them to whatever terraces are active when you go there.

As you drop off the Pitchstone Plateau and approach the town of Mammoth, you'll reach the one-way Upper Terrace Loop Drive. Near its beginning is a trail leading to Canary Spring, one of the most active terraces today. Since this spring faces south, it can be photographed at any time during the day. Good sidelighting in the morning or afternoon will bring out the texture and colors of this terrace. A wide-angle shot will show the entire terrace; a moderate telephoto lens can be used to concentrate on specific patterns. All of the terraces are extremely bright, and you'll need to adjust the exposure by opening up one to one and a half stops. Bracketing will allow you to obtain at least some photographs with the correct exposure. A polarizer will cut the reflections from the running water and make the colors more saturated, and an enhancing filter will make the warmer tones more vivid.

Farther along the Upper Terrace Loop is one of the more permanent features at Mammoth: Orange Spring Mound. Midmorning to mid-afternoon is the best time to photograph this terrace. Orange Spring Mound can be photographed from the south or the west side. You can get some excellent telephoto shots of the colored patterns in the travertine and the snags that have been killed and then engulfed by the expanding terrace.

Returning to the main loop road, down the hill are parking areas near the lower terraces. Although not as active as it was in the sixties and seventies, Minerva Terrace is still a good destination. It can be reached by a combination of boardwalk and stairs from any of the

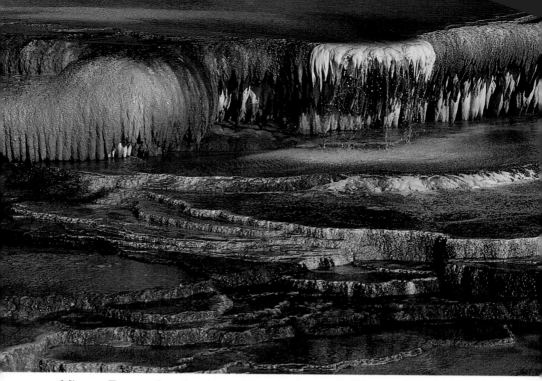

Minerva Terrace, though not as active as it once was, still has an abundance of colors and patterns. A short telephoto lens allows you to concentrate on details, and a polarizing filter eliminates the shine on the water flowing over the formations and makes the colors more vivid. You need to allow positive exposure compensation when photographing this extremely bright subject. *Minolta 70– 210mm lens, polarizing filter, Kodachrome 200 film.*

lower parking areas. Midmorning is best for photography at Minerva Terrace, which faces east. Another feature that was born in the last few years is Palette Spring. Morning is the only time when this lovely feature, which faces northeast, receives direct sunlight. Wide-angle and moderate telephoto lenses can be used to good effect on both Minerva Terrace and Palette Spring.

Mud Volcano Area. Although most of the major thermal features in Yellowstone are on the west side of the park, one small area of interest on the eastern side is the Mud Volcano area between Canyon Junction and Fishing Bridge, just south of Hayden Valley. Though you may enjoy walking around the Mud Volcano area to observe the changes and havoc these thermal features have caused, you probably won't take many photographs.

West Thumb Geyser Basin. The West Thumb Geyser Basin on the shore of Yellowstone Lake is worth a quick visit but has limited photographic appeal. Most of the hot pools and small geysers at West Thumb

are not of the same quality as those in the Upper, Midway, and Lower Geyser Basins. Nevertheless, if the sky is clear and the air is cold, sunrise at West Thumb can produce some dramatic images taken from the west edge of the basin. On most mornings, clouds of steam billow from the thermal features into the cold air. The rising sun is diffused by this steam and creates a constantly changing and brilliantly colored scene. The steam often dissipates shortly after sunrise, so timing is critical. You may wish to include some of the nearby live pine trees or the silhouettes of dead trees, killed by the hot waters of the geyser basin, in your composition. Lenses from 50mm to 400mm all produce excellent sunrise pictures here. You'll need to use a wider aperture than your light meter reading indicates for pictures that include the diffused sun. It's a good idea to bracket your exposures.

One thermal feature that is different and interesting is Fishing Cone, on the shore of Yellowstone Lake. Folklore has it that you could catch a fish in the lake and then immediately cook it in the boiling water of Fishing Cone. Fishing Cone makes an interesting photograph in the afternoon with the deep blue waters of Yellowstone Lake in the foreground and the snow-clad Absaroka Mountains in the distance. A moderate telephoto lens will make the mountains a more prominent part of the photograph.

PHOTOGRAPHING WATERFALLS

Yellowstone has a great number of outstanding waterfalls. Precipitous terrain and abundant moisture combine to provide ideal conditions for cascades and waterfalls.

There are two primary ways to photograph waterfalls. The first is to use a shutter speed that is fast enough to render the water as our eye sees it, usually $1/30$ to $1/60$ of a second. The other is to use a slow shutter speed, $1/2$ to $1/4$ of a second, to blur the water and create a more ethereal feeling. A speed faster than $1/4$ second begins to freeze the motion of the water, and a speed slower than $1/2$ second results in a loss of detail. It is easier to achieve slow shutter speeds under overcast conditions.

It's desirable to base this artistic choice on the size and power of the waterfalls, rendering major waterfalls like the Upper and Lower Falls of the Yellowstone with a faster shutter speed and more delicate, lacy cascades like Rustic and Undine Falls with slow shutter speeds. Medium-size falls like Moose Falls, Gibbon Falls, and Tower Falls could be treated either way. You might want to experiment by photographing the falls both ways.

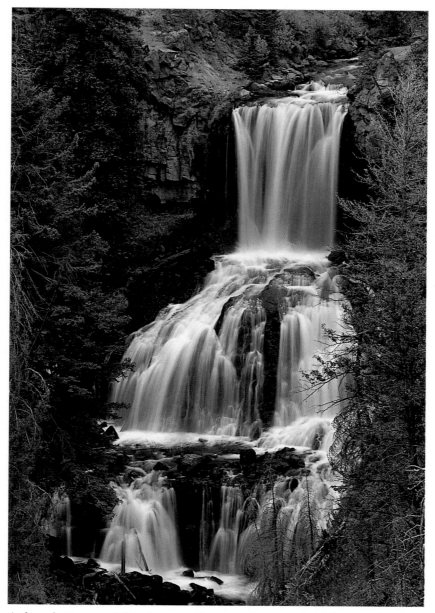

A slow shutter speed (½ of a second) was used to record this image of Undine Falls. In the autumn, when the flow of water is less than in the spring, the blurred-image treatment works very well. The scattering of autumn color around the falls is a small but important plus in this picture. *Minolta 70–210mm lens, polarizing and enhancing filters, Fuji Velvia film.*

Rainbows seem to always add interest and color to a waterfall. The spray from many falls will generate a rainbow if you are present at the right time of day and year. A properly oriented polarizing filter will make the rainbow more brilliant.

Yellowstone Canyon, Upper Falls, and Lower Falls. The Grand Canyon of the Yellowstone River, with its spectacular waterfalls, is one of the most photogenic attractions in the park. A variety of viewpoints on both the north and south rims provide spectacular views, and several trails give you a closer look at the canyon and falls.

The Yellowstone River flows northward from Yellowstone Lake through Hayden Valley until it reaches the Yellowstone Canyon. The canyon and its spectacular waterfalls were formed by a combination of lava flows and thermal action. Both the Upper and Lower Falls mark the leading edges of very resistant lava flows. The Yellowstone Canyon below the Lower Falls is carved in a less resistant volcanic rock. Geothermal activity further weakened this softer rock and made it more susceptible to the cutting action of the Yellowstone River. The canyon's beautiful colors are from the iron and manganese oxides produced by the geothermal alteration of the volcanic rocks. The plumes of steam still visible in the canyon on cool, moist mornings are evidence of continuing geothermal activity.

Photographs of Yellowstone Canyon and the Lower Falls are best taken from May through August, when the sun rises in the northeast, is higher in the sky, and produces good light through most of the morning hours. In the autumn and winter, much of the canyon and river is in shadow throughout the day, and the sun only shines on part of the Lower Falls in midmorning.

The park's Yellowstone Canyon pamphlet, available at the visitor center in Canyon Village, contains a detailed map and a lot of useful information about the canyon area. To access viewpoints and trails on the North Rim of Yellowstone Canyon, go east from Canyon Junction past the campground. This is the start of the one-way North Rim Drive. Take the spur road that branches off the North Rim Drive to Inspiration Point for an outstanding view of the Yellowstone Canyon both up- and downriver. Midmorning is the best time of day to take photographs from Inspiration Point. A wide-angle lens will allow you to photograph the whole canyon, and a telephoto lens will let you focus on details that interest you. Polarizing and enhancing filters will add color saturation.

The next stop along the North Rim Drive is Grandview Point,

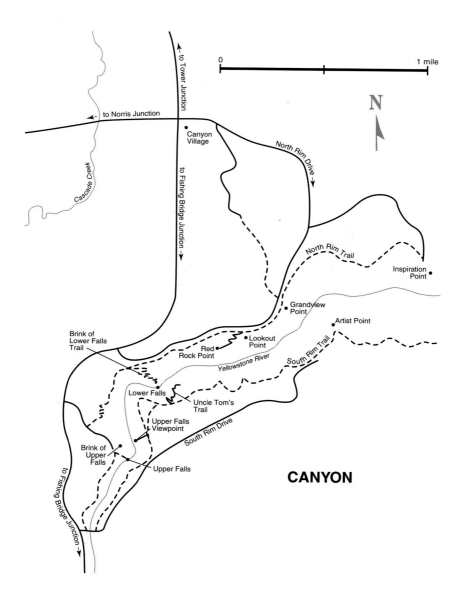

where a short walk leads to an overlook. Just beyond the parking lot is a view looking east, where the canyon and several bends in the river are attractively framed by pine trees. This is an even nicer view than that from the overlook farther along the trail. This view is best photographed from midmorning to midafternoon. You may want to eliminate the sky from this shot, as it is usually bright and distracting.

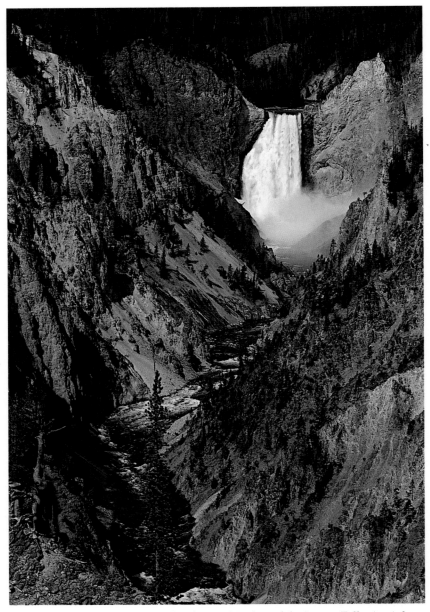

A short telephoto lens was used to frame this shot of the Lower Falls. A rainbow is visible from Artist Point at about 10:30 A.M. in the summertime. I composed this shot with the river leading up to the falls in the upper right of the photograph. The sky was eliminated because it would have been light and distracting. *Minolta 70–210mm lens, polarizing and enhancing filters, Fuji Velvia film.*

Lookout Point is an excellent spot on the North Rim that offers a variety of good compositions of both the 308-foot-high Lower Falls and the canyon. A wider shot could include the canyon with the river leading up to the falls. A telephoto shot might concentrate on the falls and the colorful cliffs surrounding it. In summer, a rainbow is visible across the falls between 9:30 and 10:00 A.M., and by late September, between 8:30 and 9:00 A.M. You may also want to shoot some of the patterns and spires in the canyon to the southeast. Ospreys nest in the canyon and are often seen by visitors.

From Lookout Point, a .75-mile round-trip trail descends 500 feet to Red Rock Point for closer views of the falls and canyon. Here, the rainbows appear slightly later.

From the next parking area beyond Lookout Point, another .75-mile round-trip trail descends into Yellowstone Canyon to a viewpoint at the brink of the Lower Falls. This spot offers an attractive view downriver that includes the brink of the falls, the spray, and the canyon beyond, best photographed in midafternoon in the summer. Those with health problems should avoid both of these trails.

Just beyond the parking lot, the one-way North Rim Drive ends at the main loop road. To the left, about half a mile south, is a spur road that leads to a parking lot near the brink of the Upper Falls. The view from the end of this quarter-mile round-trip trail is not nearly as interesting as the view from the brink of the Lower Falls, however.

About half a mile farther south along the loop road, a road branches off the main loop that crosses the Yellowstone River to the South Rim of Yellowstone Canyon. A short trail to the west of the parking area at the Upper Falls Viewpoint leads to an excellent view of the 109-foot-high Upper Falls of the Yellowstone. In early summer, a rainbow can be seen from this viewpoint at about 8:30 A.M. Later in the summer and autumn, the sun reaches the falls a little later, and the best lighting is in mid to late morning. From the viewpoint, a half-mile round-trip trail leads to another good view on the south side of the Upper Falls. A rainbow is visible here at about 10:30 A.M. Another trail, Uncle Tom's Trail, descends from the Upper Falls parking lot into the canyon to a vantage point near the base of the Lower Falls. The trail provides a fine view but is very strenuous and includes paved inclines and more than three hundred stairs.

After leaving the Upper Falls parking lot, driving east about a mile on the South Rim Drive brings you to Artist Point. The short trail from the parking area leads to an outstanding view of the distant Lower

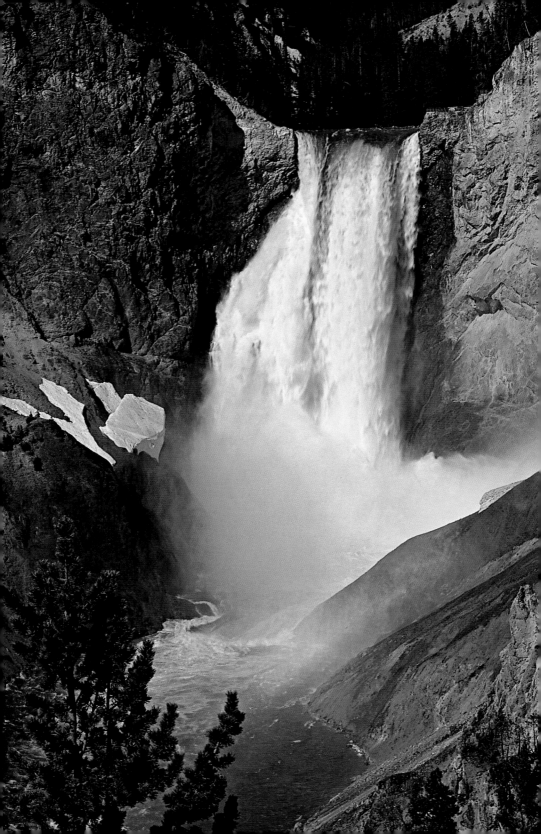

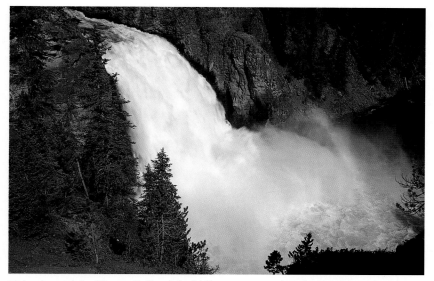

This view of the Upper Falls of the Yellowstone can be obtained by taking a short trail from the viewpoint by the parking lot around to the south side of the falls. A rainbow can be seen from this vantage point at about 10:30 A.M. *Minolta 35–70mm lens, polarizing and enhancing filters, Fuji Velvia film.*

Falls and Yellowstone Canyon. Mid to late morning provides the best lighting. In the summer, a rainbow may be visible at about 10:30 A.M. A wide range of focal lengths can be used effectively here. From the viewing platform at the end of the trail, a telephoto lens will give you interesting close-ups of the patterns and colors on the canyon walls on the north side of the river.

Tower Falls. The 132-foot-high Tower Falls, named for the towers of volcanic rock that surround the brink of the falls, is located on the main loop road about 17 miles northeast of the Yellowstone Canyon area. A short, paved path leads to an overlook of Tower Falls, one of the most beautiful waterfalls in the park, but the tall trees below make photographing the falls from the overlook difficult. You can use a moderate telephoto lens for a close-up photograph of the falls, or a wide-

The view of the Lower Falls from Red Rock Overlook is my favorite. A rainbow may be seen from this viewpoint between 9:45 and 10:00 A.M. Because this is a powerful falls, I chose a shutter speed of about ⅟₃₀ of a second to freeze the motion of the water. *Minolta 70–210mm lens, polarizing and enhancing filters, Fuji Velvia film.*

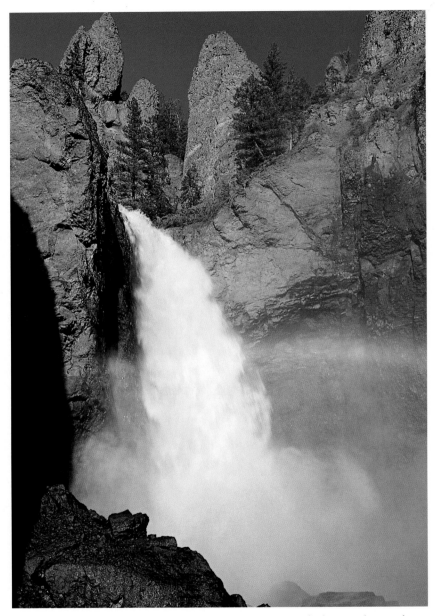

The view from the base of Tower Falls is breathtaking. If a large volume of water is coming over the falls, you and your equipment could get wet. A beautiful rainbow can be seen between 8:00 and 8:30 A.M. in the summertime. A polarizing filter, if properly oriented, will make the rainbow more vivid. *Minolta 35–70mm lens, polarizing and enhancing filters, Fuji Velvia film.*

angle lens to include the towers around the brink. In the summer, this lovely falls receives full sunlight, and morning light is best for photographs, but in the autumn and winter, when the sun is low in the sky, Tower Falls is in partial or complete shadow throughout the day. From the overlook in the summer, you may observe a rainbow between 10:00 and 10:30 A.M.

From the overlook, a fairly strenuous 1-mile round-trip trail descends into the canyon for spectacular views from the base of the falls. This is the best view of Tower Falls, and it's worth the effort to hike this trail. In early summer, when the volume of water is very high, you may encounter a lot of mist at the base of the falls, as well as a wonderful rainbow between 8:00 and 9:00 A.M. Use a soft cloth or tissue to wipe moisture from your lenses and filters between shots. In the autumn, when far less water is going over the falls, you might try a slow shutter speed, ¼ to ½ of a second, to blur the water. Wide-angle lenses are generally best for photographs from the base of the falls. A horizontal composition with a 24mm lens will capture Tower Falls and its complete rainbow. A vertical composition with part of the rainbow and the towers is interesting as well. Tower Creek and the cascades below the falls are very attractive and can also be included in a composition. The spray from the falls makes the boulders around the creek slippery; exercise caution if you leave the trail.

Other Yellowstone Waterfalls. Undine Falls is a beautiful, lacy cascade located on Lava Creek about 5 miles east of Mammoth, along the main loop road toward Tower Junction. An overlook provides an attractive view. When photographing Undine Falls, blurring the water gives excellent results, especially in the autumn, when water flow has diminished. Since Undine Falls faces west and is in the shadow of the cliffs and forest most of the day, it's easy to achieve the slow shutter speeds of ¼ to ½ of a second that are necessary to accomplish this effect.

Rustic Falls is located about 5 miles south of Mammoth, along the main loop road toward Norris between the Golden Gate and Swan Lake Flat. Rustic Falls is most attractive in the spring and early summer, when the flow of water is highest. By late summer and autumn, little water flows over the falls. Since Rustic Falls faces northeast and is in a narrow canyon, direct sunlight never strikes it, even in the summer. Because of its delicate nature and the lack of direct illumination, you may want to try the slow-shutter-speed, blurred-water approach. Using a moderate telephoto lens from the edge of the road between

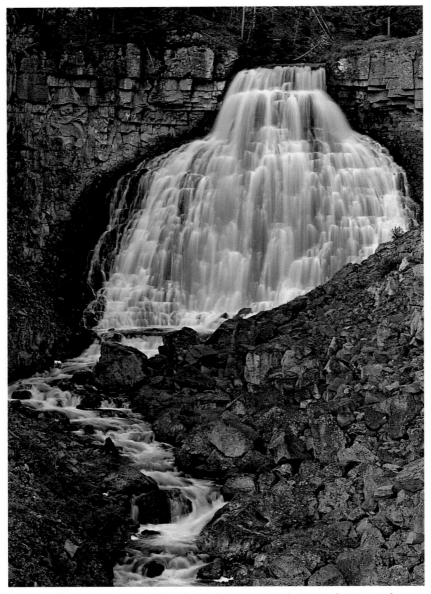

Rustic Falls is most attractive in the early summer, when an adequate volume of water is coming over the falls. By late summer, the falls has almost dried up. I prefer a composition with the stream leading up to the falls and use a slow shutter speed of ¼ to ½ of a second to blur the water. *Minolta 70–210mm lens, polarizing and enhancing filters, Fuji Velvia film.*

the parking areas above and below the falls provides a pleasing composition in which the stream leads up to the falls.

Virginia Cascade, just east of Norris Junction, is reached by a one-way road that branches off the main road between Norris and Canyon. Though this cascade is interesting, it's difficult to photograph, so you may want to skip it.

Gibbon Falls, about halfway between Norris and Madison, is one of the most attractive waterfalls in the park. The Gibbon River, a small stream known for good fishing, spreads out into a lacy, 84-foot-high waterfall that is most attractive in autumn, when the flow of water has diminished. A viewpoint and parking area are located next to the main loop road above the falls. From here, you are looking down onto the falls, and walking west a few hundred yards along the road will give you a much better view of the falls, although a few dead trees burned by the fires of 1988 impair the view. A better location for photographing the falls is from its base. No trail descends from the viewpoint, however, and the slopes of the canyon are steep and dangerous, but an unmaintained fishermen's trail leads up the bank of the Gibbon River from a picnic area about half a mile south of the falls. To reach the base of the falls, you'll have to ford the stream twice. Wear fishermen's boots, if you have them, or shoes that you don't mind getting wet. It's a lot easier to get across the stream in the autumn, when the water is low, than in the spring or summer. Take care crossing the downed tree trunks and loose rocks on the banks, as well as the moss-covered rocks in the stream.

Direct sunlight strikes Gibbon Falls from late morning to late afternoon, and midafternoon is a good time to photograph the falls. Both normal and blurred-water renditions of Gibbon Falls are attractive. To reach the slow shutter speeds of ¼ to ½ of a second needed to blur the water in direct sun, choose the smallest aperture and then use either neutral-density filters (not split neutral-density filters) or two polarizing filters at the same time to reduce the light reaching the film. You can show the stream with the falls in the background or take close-ups of the falls.

Firehole Falls is reached by a one-way spur off the main loop road just south of Madison Junction. Compositionally, Firehole Falls makes an attractive subject, with a number of well-placed pine trees for framing. However, lighting is a problem. Firehole Falls is set in a narrow canyon, faces north, and receives no direct sunlight at any time of year.

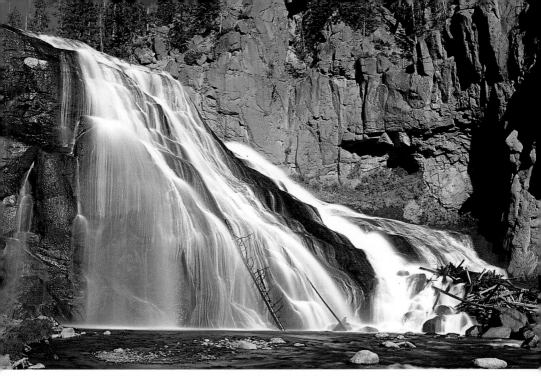

Gibbon Falls is most attractive from river level. It can be reached from the Gibbon Falls Picnic Area by following a fishermen's trail along the stream. Be prepared to ford the river in several places. To attain the slow shutter speed (¼ to ½ of a second) needed to blur the water in full sunshine, I used two polarizers simultaneously. *Minolta 35–70mm lens, enhancing and two polarizing filters, Fuji Velvia film.*

Thus photographs lack contrast and make the falls appear muddy. I've tried winter shots of Firehole Falls surrounded by snow, backlighting in the summer, and slow shutter speeds to blur the water. None of my efforts to date have yielded satisfactory results, but I intend to keep trying. Maybe you'll have better luck.

Kepler Cascades, several miles south of the Old Faithful area, can be observed from an overlook along the main loop road. Successfully photographing this long, narrow cascade is challenging, as it faces north and the forest around it contains a lot of downed timber. Blurring the water with slow shutter speeds in the autumn, when the volume of water is low, probably yields the best results.

The 29-foot-high Lewis Falls is a low but attractive falls along the south entrance road just south of Lewis Lake. Lewis Falls faces east and receives direct sunlight from midmorning to early afternoon. The banks of the Lewis River below the falls are steep, and it can be difficult to get close to the falls. A trail along the north side of the river leads from the bridge to a spot where, with a moderate telephoto lens,

a fairly good view is possible, although the foreground may be cluttered with dead logs from the fires of 1988. Wading up the river may be the only way to get to an ideal photographic position close to the base of the falls.

Moose Falls is one of my favorite waterfalls in Yellowstone. It is about a mile north of the south entrance to Yellowstone on the way to the Tetons. A short trail leads from the parking area to the base of the falls. This trail is steep and may be slippery in spots, so use caution. I prefer to photograph this lovely waterfall in the autumn, when the flow of water is low, and colorful autumn leaves may provide excellent framing. A slow shutter speed of ¼ to ½ of a second can be used to blur the water. You'll need a wide-angle lens to capture this lovely falls and its surroundings.

The Cascade Corner. The southwest portion of Yellowstone National Park contains a number of attractive waterfalls and is known as the Cascade Corner. This area is not on the main loop road and is not visited by many people. It can be reached via 42 miles of paved and gravel roads from Ashton, Idaho. Near the end of the road is Cave Falls, a 35-foot-high cascade of marginal photographic interest. The other falls, including Union Falls, Colonade Falls, Ouzel Falls, and Dunanda Falls, can be reached only by trail. The round-trip distance to these destinations ranges from 10 to 20 miles in rugged terrain. All of these falls face south or southwest and should receive adequate light for much of the day. Inquire at the Bechler Ranger Station for current information before attempting to hike to these spots.

PHOTOGRAPHING OTHER YELLOWSTONE SCENERY

Yellowstone has many other beautiful scenic attractions that make good photographic subjects. Fog and changing weather conditions can create unique opportunities anywhere in the park, so keep your camera ready.

You will be impressed by the beauty of Yellowstone Lake, but there are few other elements here to include in your compositions. One of the best locations is the Bridge Bay area just south of Lake Junction, from which the Absaroka Mountains can be seen on the east side of the lake, as well as a number of wooded islands and spits. Backlighting at sunrise or in early morning combines with the atmospheric haze to create interesting images, especially when photographed with a strong telephoto lens. The view of Yellowstone Lake from Lake Butte Overlook, about 5 miles east of Lake Junction along the East Entrance Road

This telephoto shot taken across Yellowstone Lake from near Bridge Bay uses atmospheric haze to separate the different planes in the picture. Backlighting accentuates this effect. Shade your lens when shooting into the sun to avoid lens flare. *Canon 150–600mm L lens with 1.4X extender, no filters, Kodachrome 200 film.*

to Cody, also makes a nice shot. From this vantage point, you can look across the lake to the Red Mountains and Mount Sheridan in the distance. I recommend a moderate telephoto lens and early to midmorning lighting.

Farther north along the Yellowstone River on the main loop road, you'll pass Le Hardy Rapids, which are interesting to observe but not very photogenic. When you reach Hayden Valley, several overlooks provide good views of the valley and the river far below. A good vantage point, about midway up the valley, looks through an opening in the pine trees across a horseshoe bend of the Yellowstone River to Mount Washburn in the distance. My favorite time to photograph this scene is in autumn, when the grass in the valley is golden, and mist rises from the river in early morning.

A highly photogenic location in Hayden Valley is where Alum Creek flows into the Yellowstone River. There is an island here with a small group of trees growing on it. Fog is common in early morning, and at sunrise, if the amount of fog is just right, the sun is diffused but

still visible and combines with the trees and fog to create very special images. You may have to visit this location several times to get just the right amount of fog. Too much fog will obscure the trees or the sun, and with too little fog, the sun will flare your lens. Alum Creek is also a good place to look for bison, elk, and geese to include in the overall scene.

The 2-mile stretch of the main loop road from the Fountain Paint Pot parking area to the start of the Firehole Lake Loop Drive crosses a marsh fed by numerous hot-water streams. Fog is common in early morning. The many dead trees that have been killed by the silica-laden waters, when combined with fog, can make excellent subjects. Moderate telephoto lenses are the most useful for recording the patterns in this area.

About a mile east of the Midway Geyser Basin on the main loop road are two viewpoints that provide impressive views of the Firehole River. Looking south, the stream makes a horseshoe bend that can be photographed with a very wide-angle lens. Early morning is best. To

To capture the sun, trees, and fog at Alum Creek, just the right amount of fog must be present. If there is too little fog, the sun will flare the lens, and too much fog obscures the trees and sun. Your exposure reading should be taken on the sky away from the sun. *Minolta 70–210mm lens, enhancing filter, Fuji Velvia film.*

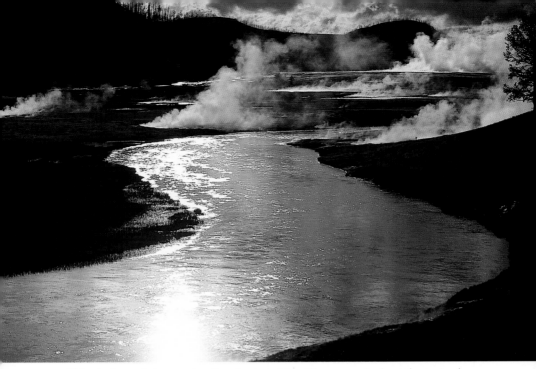

This shot was taken under threatening skies. The sun poked out for just a few minutes, backlighting the steam and making the river shine. The curve of the river is one of the most important elements in the success of this photograph. It's especially important to bracket exposures when photographing scenes with extreme contrast. *Minolta 70–210mm lens, enhancing filter, Fuji Velvia film.*

the west, several graceful bends in the Firehole River lead to the thermal features of Midway Geyser Basin. Late-afternoon backlighting can yield spectacular results, with the sparkling stream and plumes of steam highlighted against a dark background.

Although the mountains in Yellowstone are not as spectacular as the Tetons, the right atmospheric conditions and composition can make them good photographic subjects. Dunraven Pass between Canyon and Tower and the upper Lamar Valley along the Northeast Entrance Road offer good opportunities to photograph the Absaroka Mountains. The Blacktail Plateau between Tower and Mammoth and Swan Lake Flat between Mammoth and Norris have fine views of the Gallatin Range, Mt. Holmes, and Electric Peak.

PHOTOGRAPHING YELLOWSTONE IN AUTUMN AND WINTER

Yellowstone offers some unique scenic possibilities in autumn and winter. Autumn brings a wide range of temperatures and changing weather conditions. Significant snowstorms can occur in September, but

Indian summer often prevails, with clear skies and temperatures reaching into the seventies in the afternoon. However, temperatures are near or below freezing early in the morning, and you need to be prepared for temperature extremes and sudden changes in weather.

The meadow grasses, which have been green during the summer, now change to gold. Other plants turn brilliant colors. Sparkling frost crystals may be found on the grasses in early morning. Thin ice forms on ponds during the cold, crisp nights.

You can find multihued underbrush just east of Mammoth on the way to Tower and along the Lewis River just south of Lewis Falls on the South Entrance Road. Colorful ferns can be found just south of Gibbon Meadow between Norris and Madison and along the Firehole Lake Loop between Madison and Old Faithful. A moderate telephoto lens or macro lens will give you good close-up shots. For the most effective close-ups, don't include too much. Crop tightly, keep the composition simple, and focus in on the most interesting portions of the scene.

In the autumn, the ferns and underbrush in Yellowstone become very colorful. Always be on the lookout for the small patterns in nature in addition to the grand scenes. I helped nature out a bit by adding the red leaf to provide a center of interest. *Tokina 90mm macro lens, enhancing filter, Fuji Velvia film.*

Most of Yellowstone is pine forest, and there aren't as many trees that change color as in the Tetons. Quaking aspens, which turn gold in late September, are found in only a few limited areas of Yellowstone, primarily near Mammoth and along the main loop road between Mammoth and Tower, between Tower and Canyon, and in the Lamar Valley along the Northeast Entrance Road. Aspens, with their beautiful white trunks, make fine photographic subjects throughout the year but are especially appealing in autumn. Whereas in the Tetons aspens can be used to frame the jagged peaks, in Yellowstone they often serve as the subject. Wide-angle shots pointing up from below will show their trunks and striking foliage against the sky. With a telephoto lens, the aspens can make a contrasting center of interest in a green pine forest.

Winter in Yellowstone is a time of great beauty if you and your equipment are able to function in the typically frigid conditions. Daytime temperatures usually range from 0 to 30 degrees F, and on clear nights, the temperature can drop to −40 degrees F. Heavy snowfall may occur at any time.

To keep your camera and batteries warm, leave the camera in the car or under your coat until you're ready to take a picture. You'll need extra camera batteries on hand, as the cold temperatures drain battery power quickly. Winter pictures usually require a lot of positive compensation to keep the snow white; you'll need to open up about one and a half stops. Kodachrome 200 and Fuji Sensia 100 are good films to use for pure whites. An 81A filter will counter any excess bluishness caused by a clear sky. At sunrise or sunset, Velvia with an enhancing filter will provide greater color saturation.

The Mammoth Hot Springs Hotel and Old Faithful Snow Lodge, in the park, and Gardiner, West Yellowstone, and Flagg Ranch, just outside the park, provide winter accommodations and visitor services. Advance reservations are highly recommended.

Winter travel on Yellowstone's 150 miles of groomed roads is only possible using over-the-snow vehicles. Snowcoach services into and around Yellowstone are available at Mammoth Hot Springs, West Yellowstone, and Flagg Ranch. These vehicles carry up to twelve passengers and are heated. The drivers provide information about the scenery and wildlife. Numerous stops provide the opportunity to photograph along the way. Half-day and full-day trips are available to many different destinations within the park, including Old Faithful, Canyon, and West Thumb Geyser Basin. Snowmobiles and snowmobile clothing are available for rent at Mammoth, Old Faithful, West

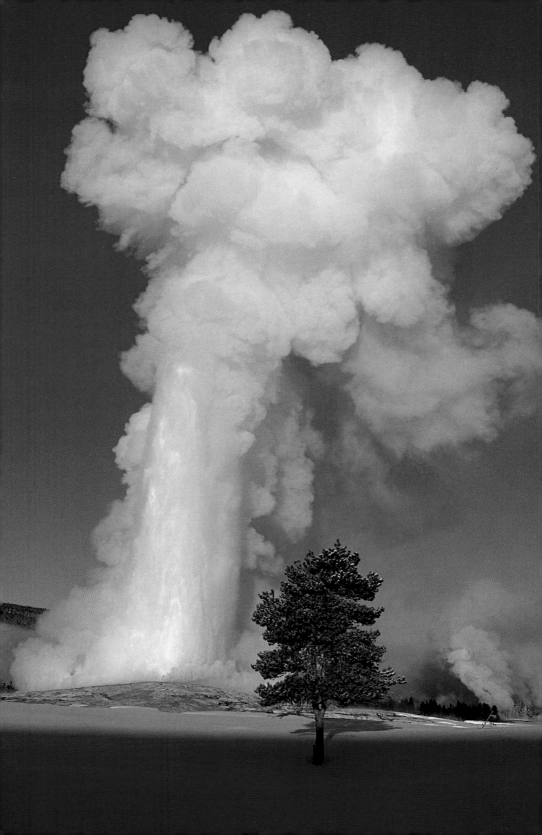

Yellowstone, and Flagg Ranch. Renting a snowmobile allows greater flexibility in your photographic endeavors but is much more expensive and a colder experience for you and your equipment. For current information and prices of the services available in Yellowstone in the winter, contact TW Recreational Services, (307) 344-7311.

I like to base my wintertime activities in Gardiner, Montana. Gardiner is the warmest spot in the Yellowstone area in the winter, with temperatures 20 degrees or so higher than most of the park. At an elevation of 5,300 feet, Gardiner is 2,000 feet lower than the Yellowstone Plateau, and as it's on the eastern side of the Continental Divide, it frequently benefits from the warming of downsloping chinook winds. Most important, Gardiner provides access to the only road in Yellowstone that's open for regular motor vehicle traffic in the winter—the road from Mammoth to Tower Junction and on through the Lamar Valley to Cooke City at the northeast entrance to the park. It is regularly plowed and passable for two-wheel-drive vehicles except during extreme conditions. Good scenic and wildlife photographs can be taken along this road without the expense of snowcoach or snowmobile travel.

From the Blacktail Plateau just east of Mammoth, the Gallatin Range and Electric Peak make good morning subjects. In the upper end of the Lamar Valley, the lofty peaks of the Absaroka Range provide good photographic material. Patterns of snow, rocks, frozen streams, ice crystals, and frosted trees will stimulate your imagination.

On your winter visit to Yellowstone, I recommend taking several trips by snowcoach to destinations within the park. You can take a snowcoach from Mammoth in the morning, arriving at Old Faithful just after noon. Along the way are great views of the Gallatin Range and Electric Peak from Swan Lake Flat, Gibbon Falls, Firehole Falls and Canyon, and an ever-changing array of winter patterns and wildlife.

After arriving at Old Faithful, you can spend the afternoon exploring the Upper Geyser Basin and stay overnight at the Old Faithful

Previous page: Early one winter morning, we waited in the –20 degree cold for about forty-five minutes before Old Faithful erupted. I kept my camera under my coat so that the batteries would stay warm and the camera would work when the geyser finally did erupt. On a cold morning, the steam rises hundreds of feet into the sky. Positive exposure compensation was needed to render the steam and the snow as white. *Canon 28–105mm lens, 81A filter, Fuji Sensia 100 film.*

Snow Lodge. Near sunset, look for colorful pictures with the Firehole River and steam from the thermal features. The next morning, you can catch the first eruption after daybreak of Old Faithful. On a cold, clear morning, the column of steam from the eruption can shoot hundreds of feet into the blue sky. Choose a lens that's wide enough to include the whole column of water and steam.

Many of the other geysers in the Upper Geyser Basin, such as Castle, Grand, Plume, Riverside, and Daisy, also make good wintertime subject material when the sky is blue and you can position yourself upwind from the eruption. Hot springs are generally difficult to photograph in the winter, because they are usually obscured by large amounts of steam. The steam from the thermal features may cause nearby trees to be coated with frost. These "ghost trees" make wonderful photographic subjects. The afternoon snowcoach trip back to Mammoth will provide more opportunities for photographs of Yellowstone's scenery, animals, and winter patterns.

Another good snowcoach trip from Mammoth is a day trip to the Yellowstone Canyon area and Hayden Valley. The Lower Falls of the Yellowstone is usually encased in a layer of ice, and the views of the canyon are magnificent. In Hayden Valley, trumpeter swans are often seen floating on the Yellowstone River. On this day trip, you'll likely have excellent opportunities to photograph wildlife as well as winter patterns.

Grand Teton National Park

WHAT TO EXPECT IN THE PARK

Most of the roads in Grand Teton National Park are open year-round. Major state and federal highways provide access to the Tetons from Rock Springs, Wyoming, on the south, Riverton, Wyoming, on the east, and Idaho Falls, Idaho, on the west. During the summer, the Tetons can be reached from Yellowstone on the north, but in the winter, the road from Yellowstone is closed to regular vehicles north of Flagg Ranch.

The major highways are augmented by the Teton Park Road, which branches off U.S. 191, 89, and 26 at Moose Junction, runs close to the base of the mountains, and rejoins U.S. 191, 89, and 287 at Jackson Lake Junction. The portion of this road between Cottonwood Creek and Signal Mountain Lodge is closed to vehicles by snow in the winter. All of the major roads in the Tetons are in good condition, and you're not likely to encounter road construction.

Several secondary roads, including the Antelope Flats Road, the Kelly Road, and the Moose-Wilson Road, provide access to other scenic areas of the park. Although the Kelly Road is open year-round, the Antelope Flats Road and the portion of the Moose-Wilson Road between Moose and Teton Village are usually closed in the winter. Portions of the Antelope Flats Road and the Moose-Wilson Road are in need of repair.

Park entrance stations, located at Moose and at Moran Junction, are open twenty-four hours a day throughout the year but may not be staffed at night or in the winter. Visitors driving north from Jackson, Wyoming, along U.S. 191, 89, and 26 and proceeding east at Moran Junction on U.S. 287 will not encounter an entrance station. Fees as of 1998 are $20 for a one-week pass good for both Yellowstone and the

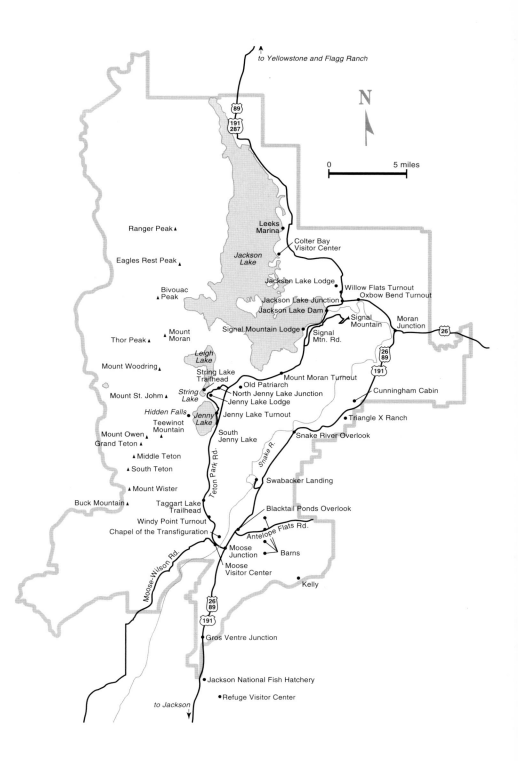

to Yellowstone and Flagg Ranch

N

0 5 miles

Ranger Peak ▲

Eagles Rest Peak ▲

Bivouac
▲ Peak

Thor Peak ▲

Mount
Moran

Mount Woodring ▲

Mount St. John ▲

Mount Owen ▲
Grand Teton ▲

▲ Middle Teton

▲ South Teton

▲ Mount Wister

Buck Mountain ▲

Leeks
Marina

Colter Bay
Visitor Center

Jackson
Lake

Jackson Lake Lodge

Willow Flats Turnout
Oxbow Bend Turnout

Jackson Lake Junction

Jackson Lake Dam

Signal
Mountain

Moran
Junction

26

Signal Mountain Lodge

Signal
Mtn. Rd.

26
89

Leigh
Lake

191

String Lake
Trailhead

Old Patriarch

Mount Moran Turnout

Cunningham Cabin

String
Lake

North Jenny Lake Junction
Jenny Lake Lodge

Hidden Falls

Jenny Lake Turnout

Triangle X Ranch

Teewinot
Mountain

Jenny
Lake

South
Jenny Lake

Snake River Overlook

Snake R.

Teton Park Rd.

Swabacker Landing

Taggart Lake
Trailhead

Blacktail Ponds Overlook

Windy Point Turnout

Antelope Flats Rd.

Chapel of the Transfiguration

Moose
Junction

Barns

Moose-Wilson Rd.

Moose
Visitor Center

Kelly

26
89

191

Gros Ventre Junction

Jackson National Fish Hatchery

Refuge Visitor Center

to Jackson

Tetons; $50 for a Golden Eagle Pass, good for all federal lands for one year; and $10 for a Golden Age Pass, good for life on all federal lands for those over age sixty-two.

Jackson is the major town serving Grand Teton National Park. Jackson is no longer a sleepy little cowtown; it's now crowded, expensive, and trendy. It has a large variety of motels, restaurants, art galleries, and shopping areas, as well as a good hospital. Nearly everything you'll need for your trip, including photographic equipment and supplies, is available in Jackson, but don't expect discount prices. Motels are expensive, especially during the main tourist season from late May through September, with rooms starting at about $80.

Lodging, ranging from rustic to luxurious, is also available inside Grand Teton National Park. Colter Bay Village, at the north end of the park, offers rustic cabins and bungalows that are comfortable and provide a quiet, relaxed atmosphere in contrast to the bustling town of Jackson. Other facilities at Colter Bay Village include a coin laundry, public showers, and a general store with groceries, clothing, and tourist supplies. Jackson Lake Lodge, several miles south of Colter Bay, and Signal Mountain Lodge, on the Teton Park Road south of the Jackson Lake Dam, have more modern facilities. Jenny Lake Lodge, close to the mountains, offers more upscale accommodations. All of these facilities are open from late May through September. For reservations at Colter Bay or Jackson Lake Lodge, call Grand Teton Lodge Company, (307) 543-2811; for Signal Mountain Lodge, call (307) 543-2831; and for Jenny Lake Lodge, call (307) 733-4647. Reservations should be made as far in advance as possible.

Grand Teton National Park has five campgrounds: Lizard Creek, Colter Bay, Signal Mountain, Jenny Lake, and Gros Ventre. Jenny Lake is for tents only; the other four accommodate tents, trailers, and RVs, although there are no hookups. A modest fee is charged, and campsites are on a first-come, first-served basis. A number of campgrounds without hookups are found in the national forests surrounding Grand Teton National Park. Camping with hookups for RVs and trailers is available outside the park at Flagg Ranch on the north, Hatchet on the east, and several locations in Jackson.

One of your first stops should be at a visitor center to obtain information, maps, pamphlets, and books on the park. Visitor centers are located at Colter Bay and Park Headquarters at Moose. A more limited facility, primarily to provide information about backcountry camping,

hiking, and climbing, is located at South Jenny Lake. No special rules apply to photographers in Grand Teton National Park.

PHOTOGRAPHING TETON SCENERY

Since the Teton Range faces east, the best photographs of these spectacular mountains are taken in the morning hours. At sunrise, the Tetons glow red as the first light from the sun strikes the peaks. At dawn, fog often hangs in the valley below the peaks, especially along the Snake River, Jackson Lake, and String Lake. It usually burns off about an hour after sunrise. For the first few hours of the day, the light is soft and warm and creates pleasing images. On most spring and summer days, even when the day dawns clear, a few clouds start to appear by late morning. The clouds usually continue to build during the early afternoon. By late afternoon, a brief thunderstorm may occur, but the sky usually clears as sunset approaches. Depending on the number of clouds remaining, you may be treated to a spectacular sunset above and behind the peaks.

The Cathedral Group, including Grand Teton, Mount Owen, and Mount Teewinot, is the highest and most attractive group of peaks in the range. These photogenic peaks take on different shapes and relationships to each other when viewed from different spots in Jackson Hole. Mount Moran, the highest mountain north of the Cathedral Group, also provides a good center of interest and dominates photographs from the northern end of the valley.

Jackson to Moran Junction. Just north of Jackson, the main highway ascends a bluff and the Teton Range comes into view. On the right is a parking area adjacent to a sign reading, "Entering Grand Teton National Park." From this spot, with a 300mm to 400mm lens, you'll be able to capture close-ups of the highest peaks in the range. This shot is especially effective at sunrise or late afternoon because of strong sidelighting and warm light. Clouds swirling around the peaks create interesting moods. Polarizing and enhancing filters can be used to good effect from this viewpoint.

For highly photogenic views of the Cathedral Group, continue north about a mile from Moose Junction to the Antelope Flats Road and turn east. About a mile and a half from the main highway, you'll encounter a north-south gravel road that leads to four old homesteads. These farms were once known as "Mormon Row," and all contain excellent foreground material for photographs of the Tetons. Two are located

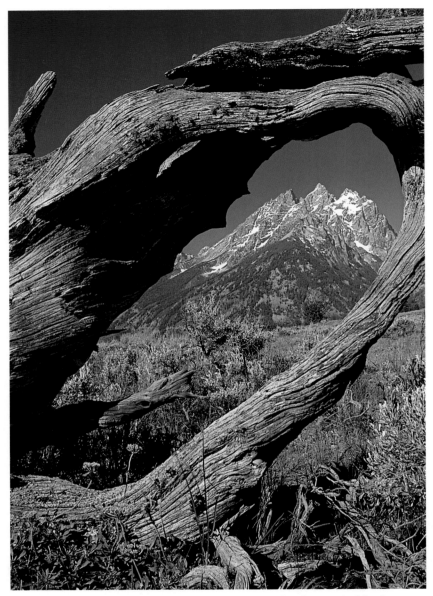

The Tetons are one of the most beautiful mountain landscapes in North America. For this shot, taken at 35mm focal length, I chose an aperture of f/22 and focused at the hyperfocal distance so that both the old stump in the foreground and the peaks in the background would be in sharp focus. *Minolta 35–70mm lens, polarizing and enhancing filters, Fuji Velvia film.*

north and two south of the Antelope Flats Road. Sunrise, especially in the springtime, is a good time to photograph any of these farmhouses and barns with the Cathedral Group in the background. In the autumn, the light is flatter on the scene at sunrise and not quite as interesting.

While this portion of Jackson Hole contains a mixture of private land and public land, all four of the barns described are on National Park land and can be explored without trespassing. If in doubt, always ask for permission before entering private lands. To visit the northern two farms, leave your vehicle at the small parking area just north of the Antelope Flats Road. The first farm north of the road is probably the most photogenic of all the Mormon Row barns. For an image in which the barn dominates the picture, simply walk up the old road. To obtain a view in which the barn is relatively small and the peaks dominate, you'll need to find a camera position 100 yards or more to the east of the barn. There is an irrigation ditch between the parking lot and this position, however, so you'll need to walk east from the parking lot about 100 yards on the Antelope Flats Road until you've crossed the ditch, and then walk through the sagebrush to your chosen camera position. If you try to reach this camera position before dawn to photograph at sunrise, you'll need a flashlight to avoid stepping in a rodent hole or tripping over the sagebrush.

A good composition can be had by placing the barn in the lower right, with Grand Teton in the upper left and Mounts Owen and Teewinot above the barn. When the sun first hits the peaks, it won't be on the barn. To photograph this scene, or any of the other barns at sunrise, use a split neutral-density filter, with a difference of at least two stops between the clear and dark portions, in addition to a polarizer and an enhancer. Once the sun reaches the barn, you won't need the split neutral-density filter. Some of the other buildings on this farm have doors and windows that make interesting patterns. Behind the barn are numerous fences, gates, and corrals, many of which can be used to effectively frame the Tetons.

An excellent shot of the northernmost barn is from the Antelope Flats Road about 100 yards east of the parking lot. A 200mm lens will include the barn with Mount Moran in the background. In the autumn, the sun is at just the right angle to obtain strong sidelighting with this composition. You can reach the barn by walking north up the old road about half a mile from the parking lot. From this spot, you can photograph the barn with the Cathedral Group for a backdrop.

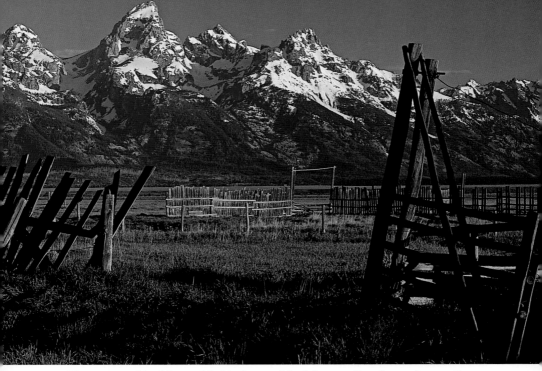

The gate on this old corral behind one of the Mormon Row barns frames the Cathedral Group. In early summer, morning shots of the barns benefit from good sidelighting. The abundance of snow on the peaks makes the Tetons more attractive at this time of the year. *Minolta 35–70mm lens, polarizing and enhancing filters, Fuji Velvia film.*

To photograph the two barns south of the Antelope Flats Road, drive south on the gravel road about half a mile to the first barn. A small parking area is provided. To get to the best camera positions, you'll need to cross the fence by the road. If a strand of the wire is not already down and you don't like climbing over barbed-wire fences, you can enter the area from a gate about 200 yards to the north of the parking area. Many good compositions of this barn with the Cathedral Group in the background are possible. Early-morning light in the springtime is best for good sidelighting. Use polarizing and enhancing filters.

The collapsing southernmost barn can be reached by driving about a quarter mile farther south along the gravel road. On the way, you'll pass several farm buildings that are still occupied by the owners. Please respect their privacy and do not trespass. The gravel road ends north of a creek. The bridge over the creek was weakened by flooding several years ago and can be safely crossed on foot but not by vehicle. Walk about a quarter mile south to get a view of the barn with the Cathedral Group in the background. (I hope that by the time you reach this spot,

the barn will not have totally collapsed.) An effective image can be taken with a short telephoto lens from just outside the fence by the road, placing the barn in the lower right portion of the frame.

Farther north on the Jackson Hole Highway, you'll reach a turnoff to the Blacktail Ponds Viewpoint, which is only about a quarter mile up the road. Looking north along the river valley from the viewpoint, you'll see several ponds about half a mile from the parking lot. A fishermen's trail leads along the top of the bluff and drops into the valley close to the first pond. Descend the bluff carefully, as the rocks are unstable.

A vertical shot including the Cathedral Group and its reflection, as well as submerged rocks and green pond scum, makes a good composition. Look for a little inlet on the far side of the pond leading up to the peaks. Midmorning in the summertime or midafternoon in the autumn will provide good sidelighting for this shot. A polarizing filter will bring out the rocks below the water surface. You'll probably need a one-stop split neutral-density filter to even out the exposure difference between the mountains and their reflection on the surface of the sunlit pond.

Proceeding north on the Jackson Hole Highway, you'll pass the Glacier View Turnout and reach a gravel road leading to Schwabacher Landing on the Snake River. From the parking lot, a fishermen's trail leads north along the banks of a small backwater of the Snake. This small stream, with Mount Moran to the northwest, makes an interesting image with good sidelighting early in the morning or late in the afternoon. Both horizontal and vertical compositions are equally pleasing.

Continuing north on the path along the stream for about a quarter mile, you'll arrive at a pond that often has beautiful reflections of the Cathedral Group to the west. Including some of the grass on the near shore will give a feeling of depth to the picture. The light on this scene is generally flat until late morning. To even out the exposure between the peaks and the reflection, use a two-stop split neutral-density filter if the pond is in shadow or a one-stop split neutral-density filter if sun is on the foreground. You can use a wide-angle or moderate telephoto lens for a variety of compositions with trees framing the peaks.

Farther north on the Jackson Hole Highway, you'll reach the Snake River Overlook. From this bluff, you can see the Snake River leading up to the majestic peaks of the Tetons in the background. The lighting from the Snake River Overlook is flat at sunrise but improves by mid to

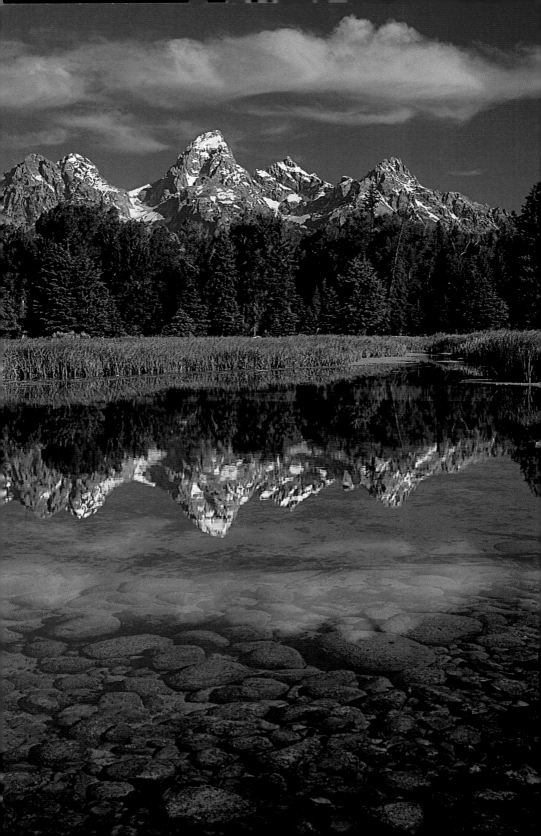

late morning. The best compositions can be obtained at the north end of the overlook. Even though pine trees below the overlook obscure portions of the Snake River, this view is still outstanding. A short telephoto lens and a vertical format will allow you to concentrate on the river and the Cathedral Group.

Beyond the Snake River Overlook, the Jackson Hole Highway turns east and descends into a broad valley containing a number of ranches. Attractive buck-and-rail fences line this section of highway. These picturesque fences in front of the peaks make wonderful images. One of the best spots to photograph is near the turnoff leading to the Triangle X Ranch. On the west side of the road, the fence descends into a little gully and back up the other side, providing strong diagonal elements for compositions including the Cathedral Group. Wide-angle lenses and short telephoto lenses will both produce creative images. About a mile east of the Triangle X, just before reaching the Cunningham Cabin turnoff, is another photogenic stretch of buck-and-rail fence to the north of the road. Several groves of aspen trees make this location especially lovely in the autumn. Mid to late morning provides the best lighting for both of these locations.

The remainder of the Jackson Hole Highway south of Moran Junction winds through relatively flat terrain with unobstructed views of the Teton Range. Look for attractive cottonwood trees to the west of the highway that can be used in telephoto shots to frame the distant peaks.

Along this highway are a number of excellent locations to photograph sunsets. The Snake River Overlook is exceptionally good because of the shape of the peaks from that viewpoint. Which turnout to use depends on the time of year and which clouds have the best color. When photographing silhouettes of the peaks at sunrise or sunset, no detail will show up below the horizon, so it's usually best to place the horizon close to the bottom of the frame. Take your exposure reading off the sky. A telephoto lens will allow you to concentrate on the most photogenic peaks and the portion of the sky with the best color. An

I was fortunate to have interesting clouds in the sky above the peaks in this shot. A polarizing filter darkened the sky and removed part of the reflection on the water so that the rocks in the foreground, below the surface, could be seen. A split neutral-density filter evened out the exposure between the peaks and their reflection. *Minolta 35–70mm lens, polarizing, enhancing, and split neutral-density filters, Fuji Velvia film.*

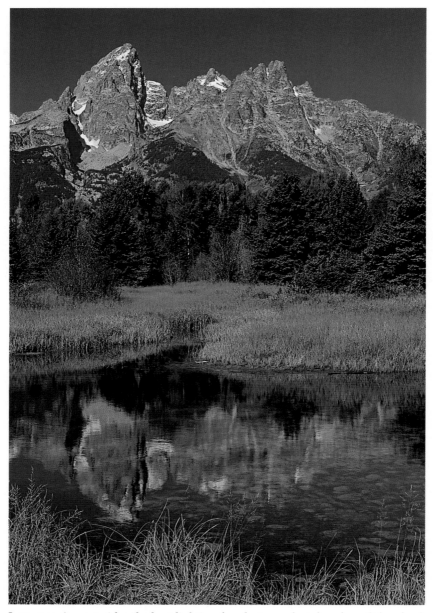

Late morning provides the best lighting for photographs taken from Schwabacher Landing. In the autumn, the grass along the edge of the pond is golden and adds color to the picture. I chose this spot because the shape of the reflection of the peaks reflects the shape of the grass on the near bank. *Minolta 70–210mm lens, polarizing, enhancing, and split neutral-density filters, Fuji Velvia film.*

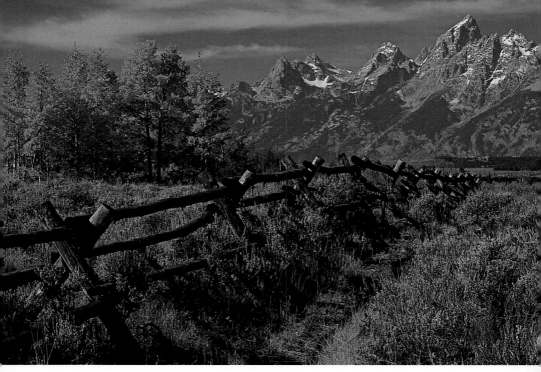

This buck-and-rail fence along the Jackson Hole Highway just west of Cunningham Cabin adds a strong diagonal compositional line to this image. The wispy clouds in the sky and the golden aspen on the left contribute to making this a successful photograph. *Minolta 70–210mm lens, polarizing and enhancing filters, Fuji Velvia Film.*

enhancing filter can make a poor sunset look good and a good sunset great.

Moran Junction to the North Boundary. After passing through the Park Entrance Station, proceed about 3 miles to the Oxbow Bend area. This body of water is a portion of the ancestral Snake River that was bypassed and has formed a lake. Rightly considered one of the prime photographic destinations in the park, Oxbow Bend frequently exhibits a beautiful reflection of Mount Moran and the surrounding peaks. Good compositions can be obtained adjacent to the paved parking lot, as well as along the road for about another quarter mile to the west. Plenty of trees, bushes, and shrubs are available for framing. A vertical shot with a short telephoto lens concentrating on Mount Moran and its reflection and a horizontal shot with a normal lens including Mount Moran and some of the surrounding peaks are both appealing.

In the summer and autumn, the lighting is flat at sunrise but good by mid to late morning. Oxbow Bend is also one of the favorite destinations in the park for sunsets. If the clouds have good color and the winds are relatively calm, the color may be reflected in the water. Be

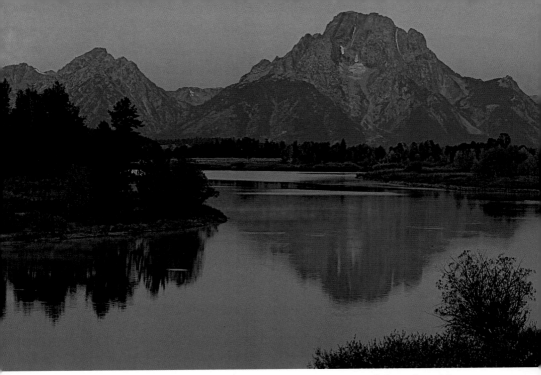

Oxbow Bend, whose still waters often reflect the peaks and the color of the sky, is one of the most photogenic locations in the Tetons. In this image, the thin cloud layer behind Mount Moran picked up color just before the sun hit the peaks. An enhancing filter accentuated the alpenglow. *Minolta 70–210mm lens, enhancing filter, Fuji Velvia film.*

sure to arrive at Oxbow Bend early so that you'll have the shooting position you want when the best color develops.

A mile beyond Oxbow Bend is Jackson Lake Junction, where the Teton Park Road joins the main road. To reach a viewpoint where the entire Teton Range stretches out before you, stay to the right at the junction and pull into a parking area about a quarter mile beyond the intersection. Though the panorama is awe-inspiring, it doesn't make a very good photograph. You can walk back along the road toward the junction or up the road toward the Willow Flats Turnout and use the aspen trees, either singly or in groups, to frame the Cathedral Group or Mount Moran. Short telephoto lenses will isolate the peaks and make more interesting compositions than wide-angle shots of the whole range.

About 3 miles north of Willow Flats, after passing Jackson Lake Lodge, the road turns west, crosses Pilgrim Creek, and runs through several large meadows with outstanding views of the Cathedral Group and Mount Moran. The trees at the far end of these meadows provide good framing for the peaks. A telephoto lens will allow you to concen-

trate on the most attractive portions of the Teton Range. Fog is often seen below the peaks from this viewpoint early in the morning and will add mood to your images. Early to midmorning provides the best lighting for pictures from these meadows.

In the spring and summer of a wet year, these meadows have wonderful wildflower displays, which can provide color and added interest to the foreground of your photographs of the mountains. Try a vertical format with a wide-angle lens set at hyperfocal distance to obtain sharp focus on both the flowers and the mountains.

Beyond the meadows, the road turns north again, passes Colter Bay, and parallels the east shore of Jackson Lake to the north boundary of the park. The northeastern shores of Jackson Lake are an excellent place to document how abruptly the Tetons rise above Jackson Hole. The farther north along the lake you go, the less attractive the principal peaks of the range become. In the autumn, however, the colorful aspens make up for the less-than-ideal view of the peaks.

The meadows just south of Colter Bay provide wonderful views of Mount Moran and the Cathedral Group. This sunrise shot of Mount Moran was taken as an autumn storm was breaking. Mood is one attribute that will differentiate your shot from those taken of the same scene by others. *Minolta 70–210mm lens, enhancing filter, Kodachrome 200 film.*

The Chapel of the Transfiguration and the fence, gate, aspen trees, and flowers, with the Cathedral Group in the background, present many interesting compositions. With any subject, you should walk around the area and examine all the possibilities before moving on. *Minolta 35–70mm lens, polarizing and enhancing filters, Fuji Velvia film.*

The Teton Park Road (Moose Junction to Jackson Lake Junction). From the junction with the Jackson Hole Highway at Moose, turn west, cross the Snake River, pass the visitor center, and go through the entrance station. About half a mile past the gate on the right is a short spur road leading to the Episcopal Chapel of the Transfiguration. This picturesque little chapel conducts services every Sunday and can be reserved for special events. (My wife and I were married there.)

A number of good photographs are possible from the chapel or nearby. Possibilities include the chapel and peaks framed by the gate in front and the buck-and-rail fence and chapel, with the Cathedral Group in the background. Inside the chapel above the altar is a plate-glass window that frames the peaks. You can take photographs through the window with the cross on the altar in the foreground. A variety of lenses, from wide-angle to moderate telephoto, will give excellent compositions of the chapel and its surroundings. The light is best in the morning hours, and if you want photographs of the chapel without people wandering around it, arrive early in the day.

A number of other good compositions are available in the immediate vicinity. A grove of aspens just west of the chapel, with the Cathedral Group in the background, makes an attractive shot, especially in autumn. The fence on the south side of the chapel can be used as part of this composition. If you photograph the chapel in the spring, large groups of balsamroot, an attractive yellow flower common in the Jackson Hole area, can be used in the foreground.

About a mile farther north on the Teton Park Road you'll reach Windy Point Turnout, an excellent place to photograph sunrise in the Tetons. You can come in tight with about 200mm on Grand Teton and Mount Owen, or if colorful clouds are present, you may want to loosen up the composition slightly. Polarizing and enhancing filters will add color to the scene and darken the sky behind the peaks.

About a mile farther up the Teton Park Road is the Taggert Lake Trailhead. A moderately strenuous 4-mile round-trip hike leads to Taggert and Bradley Lakes, small tarns that provide good views of the surrounding peaks. Mount Wister, an attractive but less celebrated peak in

Windy Point is a good location from which to photograph the magnificent peaks of the Teton Range at sunrise. I try to concentrate on the most dramatic part of the scene and eliminate less-interesting material around it by cropping in as tightly as possible. A zoom lens will allow you to compose your images precisely. *Minolta 70–210mm lens, polarizing and enhancing filters, Fuji Velvia film.*

the Teton Range, can be photographed from the trail crossing the ridge between the lakes. If you have the time, this is an interesting hike.

Just beyond the Taggert Lake Trailhead, and before crossing Cottonwood Creek, a meadow lies to the west of the road. At the far end of the meadow is a small, picturesque cabin and an attractive grove of aspen trees. The cabin and trees make a very nice composition with the Cathedral Group in the background, especially in the autumn, when the aspens are gold. Early morning in spring or midafternoon in autumn provides the best lighting. Horses are often seen in this fenced meadow and can add interest to your image. The ridge behind the cabin is scarred by some dead trees burned in a small forest fire in the 1980s, but nature is gradually repairing the damage.

North of Cottonwood Creek, the Teton Park Road passes through sagebrush flats with constantly changing views of the Tetons until it reaches the Jenny Lake area. The wildflower displays along this stretch of road, especially in mid-June with balsamroot and in mid-July with scarlet gilia and lupine, are some of the best in the park. If you spot a particularly attractive field of flowers, you might want to try shooting the Cathedral Group with flowers in the foreground. Focus at the hyperfocal distance to keep everything sharp.

Trails starting at the south end of Jenny Lake lead to Hidden Falls, Cascade Canyon, and Lake Solitude. Hidden Falls is very attractive and relatively easy to visit and photograph. Rather than hiking the extra 2.4 miles each way to get to the west end of Jenny Lake, you can take the launch that leaves from the boat dock close to the parking lot. Inquire at the Jenny Lake Ranger Station for departure times and costs. Hidden Falls is about half a mile from the boat dock at the far end of Jenny Lake. If you want to hike around Jenny Lake to the falls, the trail from the south end of String Lake is .7 mile shorter each way. To photograph the falls, you may want to try a faster shutter speed of $\frac{1}{30}$ of a second early in the season, when the water flow is high, and a slow shutter speed of $\frac{1}{4}$ to $\frac{1}{2}$ of a second in autumn, when the volume of water has diminished.

The Lake Solitude area is extremely photogenic and features views of the back side of the Cathedral Group across the lake and alpine wildflower meadows. However, the hike to Lake Solitude is a strenuous 14 miles round-trip from the boat dock on Jenny Lake, and most of the images are best taken in the late afternoon or at sunrise. To camp near Lake Solitude, you need to obtain a permit from the ranger station at

Jenny Lake, which may be difficult, as Lake Solitude is a popular destination and only a limited number of permits are issued. Also, the lake does not thaw out some years until mid-July.

Driving north on the Teton Park Road from Jenny Lake, your next destination should be the Old Patriarch tree. You may have seen photographs of the Tetons framed by this picturesque old limber pine on postcards and in books. Before the Teton Park Road was rerouted in the late eighties, you could park within a quarter mile of the tree and see it from the road. The Old Patriarch is now a little more difficult to find and requires more time and effort to visit. However, this is an advantage for photographers, since few people know where it is. You can park a few hundred yards south of the North Jenny Lake Junction and walk almost directly east for about .75 mile to the tree. On the way, you'll descend several stream terraces deposited by the ancestral Snake River; watch your footing. If you want to take pictures at sunrise, use a flashlight so that you won't trip over the sagebrush. If you reach the old abandoned road, you've gone too far; look for the tree up and down the road. Sunrise and early morning in the autumn and midmorning in the summer provide the best lighting. If you shoot when the sun first hits the peaks, and the foreground, including the tree, is still in shadow, you should use a two-stop split neutral-density filter to even out the exposure.

A vertical telephoto shot of about 135mm focal length from several hundred yards northeast of the tree, placing the tree in the lower right portion of the frame, will emphasize the size and grandeur of the peaks. A horizontal shot of about 70mm focal length from about 25 yards away from the tree, with the Cathedral Group on the left and the tree on the right, is another effective image. A third appealing composition can be taken from close to the tree with about 50mm focal length, including the colorful trunk of the tree on the right, a small grove of pine trees on the extreme left, and the Cathedral Group in the upper left third. Several attractive trees and snags, several hundred yards to the north of the Old Patriarch on top of the old stream terrace, can be used to produce other compositions. For shots which include these trees and snags, focus at the hyperfocal distance to make the entire image sharp. Polarizing and enhancing filters will make the colors more saturated.

From the North Jenny Lake Junction, you can take the one-way loop road west to String Lake. After about 2 miles, turn right onto the String Lake spur road. Pass the first parking area, near the start of the

The area around the Old Patriarch offers many photographic possibilities.
Distant, medium-range, and close-up shots including this picturesque tree are
all interesting. In the autumn, the direction of light in the early-morning
hours brings out the texture of the tree and peaks and allows good polariza-
tion. *Minolta 35–70mm lens, polarizing and enhancing filters, Fuji Velvia film.*

spur, which is for hikers going to Cascade Canyon and Lake Solitude, and park in the second parking area. At the shore of String Lake, turn left and walk several hundred yards along the trail to reach several areas that have reeds growing in the water just offshore. The Cathedral Group reflected in String Lake with these reeds in the foreground makes an attractive image. You'll need a wide-angle lens to include both the peaks and their reflection. The lighting is good at sunrise in the autumn but is somewhat flat until midmorning in the summer. You can get some nice images by arriving at this spot before sunrise and beginning to shoot as soon as the sun strikes the peaks. Fog is often present early in the morning and adds to the mood. Polarizing and enhancing filters will make the colors warmer and richer, and a split neutral-density filter will even out the exposure between the peaks and their reflection.

The String Lake spur road ends at a picnic area. From here you can walk north on a fairly level, 2-mile round-trip trail that follows String Lake to Leigh Lake. About a quarter mile up the trail are several fine views of Mount Moran towering above String Lake. One excellent viewpoint includes a little island just offshore. In the summer, the lighting is ideal early in the morning, but in the autumn, it is flat until later in the day. A wide-angle lens, polarizing and enhancing filters, and a split neutral-density filter if a reflection is present may produce the best images.

Farther along the trail, you'll pass the junction to Indian Paintbrush Canyon. Signs direct you to the canoe launch at the outlet of Leigh Lake. This spot on Leigh Lake gives another fine view of Mount Moran with a possible reflection. This scene is best photographed in early morning in the summer with a wide-angle lens, polarizing and enhancing filters, and a split neutral-density filter if there's a reflection.

The loop road next skirts the east shore of Jenny Lake. The first parking lot is about 1 mile south of String Lake. From this vantage point, Grand Teton has virtually disappeared behind Mount Teewinot, and this view is not one of my favorites. A short trail leads down to the shore of Jenny Lake, where you can see Mount Moran to the north and what's left of the Cathedral Group across the lake. If you want to photograph these peaks along with Jenny Lake, good reflections early in the morning will help. Use the rocks and trees along the shoreline for framing.

Near the south end of Jenny Lake, the one-way loop road ends at the Teton Park Road. To the north, past the North Jenny Lake Junction,

Several excellent views of Mount Moran can be found along the shore of String Lake on the trail to Leigh Lake. The perfect reflection, the wispy clouds in the sky, and the rock and reeds in the foreground all contribute to making this one of my favorite shots of the Tetons. *Minolta 35–70mm lens, polarizing and enhancing filters, split neutral-density filter, Fuji Velvia film.*

is the Mount Moran Turnout. To the northeast, there's a low ridge with a number of interesting trees that make excellent material to frame your images. You can drive past the ridge, park along the road, and then choose the framing that looks best. Early-morning fog around Mount Moran adds to the mood. In the summer, the lighting is good on Mount Moran early in the morning, but in the autumn, it's flat at that time of day.

A few miles farther north on the Teton Park Road is the spur road leading to the summit of Signal Mountain, which rises about 1,000 feet above Jackson Hole. This road is steep, narrow, and winding, but the views looking down on the valley and across Jackson Lake to the Teton Range are spectacular. The viewpoint that is reached from the parking lot a half mile west of the summit yields the best photographs.

Sunrise is a good time to photograph from Signal Mountain. Fog often hangs over the lakes at the base of the Tetons. In the summer,

The views of the Teton Range from Signal Mountain are magnificent. Fog is often present around or below the peaks early in the morning. For this composition, I chose a camera position that would place the pine trees in the lower left to balance Mount Moran in the upper right and used a telephoto lens to concentrate on the most interesting part of the scene. *Minolta 35–70mm lens, enhancing filter, Fuji Velvia film.*

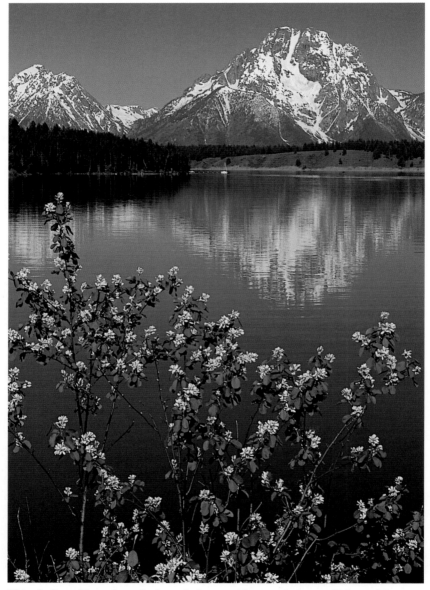

This sheltered bay along Jackson Lake provides good views of Mount Moran and the surrounding peaks. The flowering bush adds depth and interest. I carefully fit the shape of the reflection to the shape of the bush and used hyperfocal distance to make both near and distant objects sharp. *Minolta 35–70mm lens, polarizing and enhancing filters, Fuji Velvia film.*

Mount Moran has adequate sidelighting early in the morning, but lighting on the Cathedral Group is flat. In the autumn, the opposite is true. A number of pine trees grow here and provide attractive framing material. In June, balsamroot grow in profusion on the slopes of Signal Mountain and make a colorful and interesting foreground for shots of the peaks. You'll need a wide range of focal lengths to capture all of the possibilities from Signal Mountain.

After returning to the Teton Park Road, you'll pass Signal Mountain Lodge and the Chapel of the Sacred Heart. About a mile beyond the chapel, there's a turnout along Jackson Lake. In the morning hours, this sheltered bay often provides good reflections of Mount Moran and the surrounding peaks. In June, flowering bushes near the parking lot will add interest to your photographs. In the summer, the lighting is good by midmorning, but in the autumn, it's flat until late morning.

Another spot to capture a reflection of the Tetons is from the south end of the Jackson Lake Dam. There's a parking lot just east of the road. About a mile beyond the dam, the Teton Park Road ends at Jackson Lake Junction.

PHOTOGRAPHING THE TETONS IN AUTUMN AND WINTER

Autumn in the Tetons is a special time of year. Large numbers of aspen trees and narrow-leaf cottonwood trees turn gold in late September to early October. The underbrush also adds to the autumn color. Framing the spectacular peaks of the Tetons with golden foliage can produce some exceptional photographs.

The timing of the fall color in the Tetons is hard to predict. Various factors cause the color to peak early or late and to be magnificent or disappointing. The color may peak as early as September 20 or as late as early October. If unusually cold temperatures or a heavy snow arrives in mid-September, the leaves may go directly from green to brown. Some years the aspens are good and the cottonwoods are poor; other years the opposite is true. Some years the aspens and cottonwoods both turn at the same time; other years they don't. Despite the uncertainty of the timing, the last week of September will usually see the start of the fall color, the best of the fall color, or the last of the fall color.

Lighting is critical to bring out the maximum color in fall foliage. Under sunlit conditions, backlighting or strong sidelighting is much more effective than frontlighting. The colors of these translucent leaves are more brilliant when light shines through them than when light

shines on them. Strong sidelighting also maximizes the effects of polarization and makes the colors more vivid. Overcast lighting creates the best colors in close-ups of underbrush. The colors are more vivid, and no harsh shadows are present.

Many Teton locations have good color. Some spots to check out along the Jackson Hole Highway between Jackson and Moran Junction are near the Snake River on the Schwabacher Landing Road, at the Snake River Overlook, between the Triangle X Ranch and Cunningham Cabin, near Moosehead Ranch, the Mormon Row barns, and the Blacktail Ponds area, where cottonwood trees and colorful bushes sometimes combine to give good fall color. Groups of cottonwood trees, which can be used to nicely frame the Cathedral Group, are found along the road between Spread Creek and the Buffalo River.

Along the road between Moran Junction and the northern boundary of the park, the best autumn color location is at Oxbow Bend, where a particularly beautiful grove of aspens, which frequently exhibits reds and oranges as well as golds, is situated just below Mount Moran. The golden willow bushes and orange sumac bushes at Oxbow Bend make an extremely attractive foreground. Great compositions and color can be found from the paved parking area west along the road for a quarter mile.

About half a mile east of Oxbow Bend is a viewpoint overlooking a grove of aspen trees and Mount Moran. You can find several good shots from the meadow between the parking lot and the trees. A telephoto lens can be used to isolate Mount Moran and the colorful foliage. Late morning is the best time for strong sidelighting at both this location and Oxbow Bend.

The grove of aspens just north of Jackson Lake Junction also yields excellent results. Early to midmorning provides good lighting for shots including the Cathedral Group, and late morning is best for shots of Mount Moran. The aspens on the road north of Colter Bay along Jackson Lake provide some exceptional color in most years. Even though the views of the Tetons are not as spectacular from this area, the outstanding autumn color may make up for it. Early morning provides the best lighting for shots along Jackson Lake.

Several areas along the Teton Park Road from Moose Junction to Jackson Lake Junction are good autumn destinations. The area around the Chapel of the Transfiguration is surrounded by aspens and cottonwoods and presents multiple photographic opportunities. The lighting is best in early to midafternoon. Another noteworthy location is along

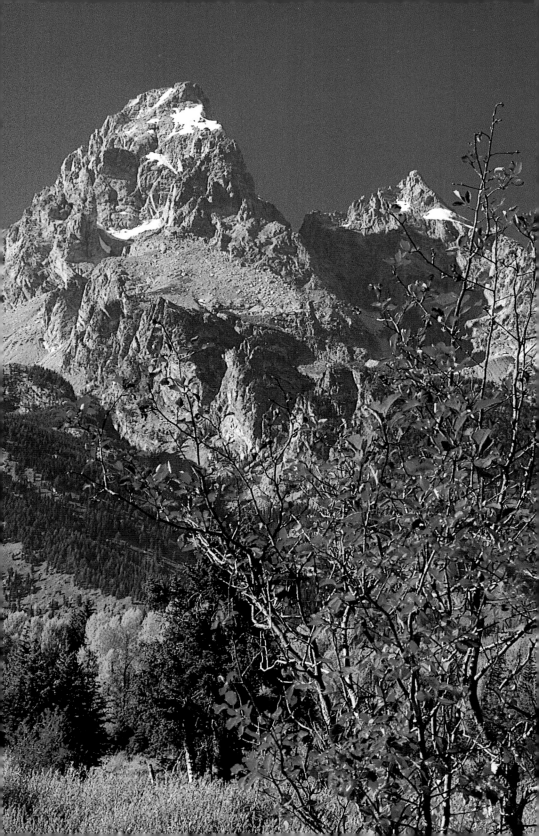

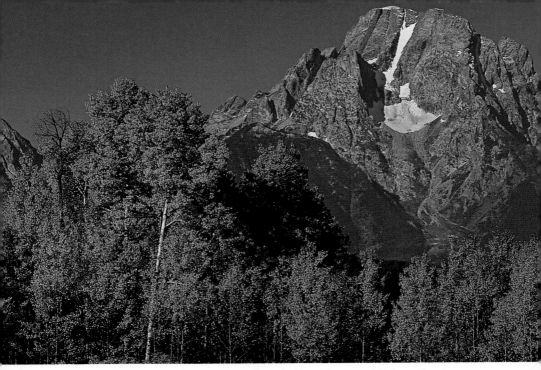

This image was taken from an area about half a mile east of Oxbow Bend, where each autumn a beautiful grove of aspen trees consistently provides one of the most colorful foregrounds in Jackson Hole. I positioned Mount Moran in the upper right of the frame and the most dominant group of aspen trees in the lower left. *Minolta 70–210mm lens, polarizing and enhancing filters, Fuji Velvia film.*

the shore of Jackson Lake between the Chapel of the Sacred Heart and the Jackson Lake Dam. Late morning is best for photos here.

Some of the best underbrush color in the Tetons can be found along the Signal Mountain Road and near the entrance to the Signal Mountain Campground. Another good location is along the Moose–Wilson Road, where buck-and-rail fences add interest to images of the colorful foliage.

Winter brings an entirely different mood to Jackson Hole. The Tetons are obscured by clouds and snow most of the winter months. Sometimes temperature inversions occur, and even though the tops of the peaks are clear, Jackson Hole is shrouded in fog. But when the clouds and fog part, those magnificent peaks are revealed in all their beauty.

Because of the uncertain weather, you may not want to plan a photographic trip in the wintertime with the Tetons as the sole destina-

Previous page: Colorful trees and bushes provide framing for the Tetons in this photograph taken near Blacktail Ponds. Compositionally, the colorful bush at the lower right balances Grand Teton at the upper left. *Minolta 35–70mm lens, polarizing filter, Kodachrome 200 film.*

The Moose-Wilson Road provides access to some of the most colorful areas of underbrush in Jackson Hole. This group of foliage was particularly attractive along with the old buck-and-rail fence. By cropping in tightly and not including all of the fence, I was able to concentrate on the most interesting and colorful portion of the scene. *Minolta 70–210mm lens, enhancing filter, Fuji Velvia film.*

tion. I once spent an entire week there without seeing the peaks. If you plan to visit Yellowstone on the same trip, however, or want to downhill ski in the Tetons, it won't ruin your trip if the weather in the Tetons isn't ideal. Most motels and restaurants in Jackson are open in the wintertime to cater to skiers, and the prices for lodging are less expensive than in the summertime.

Be prepared for bitterly cold temperatures, especially at sunrise, if the weather is clear. Dress warmly to avoid frostbite. Keep your camera warm when not in use to conserve battery power.

For white snow in your photographs, exposure compensation should be about one and a half stops in a positive direction. For exposures at sunrise or sunset, not as much positive compensation is required, because the snow is red or orange and much of the picture may be in shadow.

The Jackson Hole Highway from Jackson to Moran is open all winter. Many of the same viewpoints that are good in summer or autumn are also excellent in winter, including Blacktail Ponds Viewpoint, the

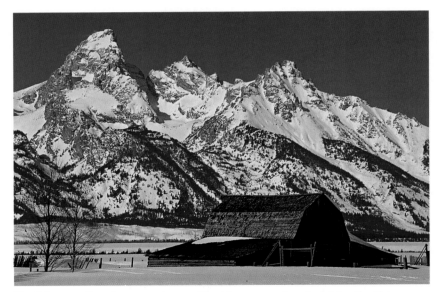

The Mormon Row barns make excellent foreground material for the Tetons in the winter. But since the Antelope Flats Road is usually closed then, you'll have to cross-country ski or snowshoe to reach them. Because of good sidelighting, early afternoon is the best time to photograph the barns in the wintertime. *Minolta 70–210mm lens, polarizing and enhancing filters, Fuji Velvia film.*

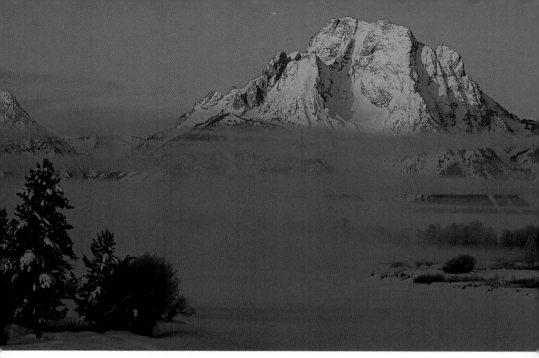

A winter sunrise at Oxbow Bend is spectacular. Be prepared for bitterly cold temperatures, and keep your camera warm until you're ready to take your pictures. Polarizing and enhancing filters will make the sunrise colors more vivid. *Minolta 70–210mm lens, polarizing and enhancing filters, Fuji Velvia film.*

Snake River Overlook, and the area between Triangle X Ranch and Cunningham Cabin. The Antelope Flats Road is usually closed during the winter months, but you can rent cross-country skis or snowshoes in Jackson to visit the Mormon Row barns.

Several miles east of Moran Junction toward Dubois, beyond the Buffalo River, are a buck-and-rail fence and gate that, along with a strategically placed tree, make a wonderful winter photograph with the Tetons in the background. The road from Moran Junction to the northern end of the park is open all the way to Flagg Ranch in the winter. Oxbow Bend is an excellent spot along this road for winter photographs. Sunrise from Oxbow Bend, with the fog hanging below the peaks, is spectacular. The views from the meadows just south of Colter Bay are also good.

Only limited parts of the Teton Park Road are open to motor vehicles in the wintertime. To the south, the road ends at Cottonwood Creek. To the north, only the portion of the road from Jackson Lake Junction to Signal Mountain Lodge is open. The remainder of the road is open to snowmobilers with permits and to persons on cross-country skis or snowshoes.

Wildlife

Yellowstone and Grand Teton National Parks are famous for the quantity, quality, and visibility of wildlife. Although good opportunities to photograph wildlife exist throughout the year, autumn is probably the most productive season. Professional and advanced amateur photographers from all over the world converge on the northwest part of Wyoming in late September and early October to document the mating activities of elk, bison, moose, and antelope.

During the bitterly cold winters, the hooved animals face a bleak, uncertain future as they search for food in the deepening snow. Predators and scavengers take advantage of the opportunities provided by the hardships of winter. The lower elevations in the northern part of Yellowstone attract large herds of elk and bison in the wintertime, when grazing and browsing in the higher elevations of Yellowstone becomes difficult. These animals can often be photographed near the road between Mammoth and Cooke City. Coyotes are frequently seen, sometimes devouring the carcass of an elk or bison that has succumbed to the harsh conditions. Packs of the newly introduced wolves may often be observed at a distance, especially in the Lamar Valley. Bighorn sheep might be seen in the Gardiner River Canyon and near Soda Butte in the Lamar Valley. Bison and elk are usually seen at close range in the geyser basins, since they often seek the relatively mild conditions and easier foraging that the basins provide in the wintertime.

Wildlife photography may be the most difficult kind of photography. First, there is no guarantee that you will find any wildlife. Your subject may decide to run or fly away, it may never look up, the lighting may not be strong enough or at the correct angle, the background may be terrible, there may be distractions in the foreground, or other

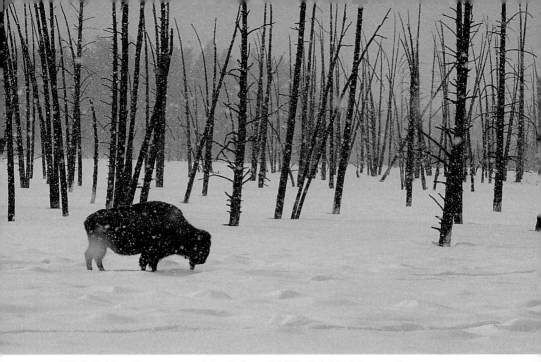

While taking the snowcoach back from Old Faithful to Mammoth, we came upon several bison in front of a photogenic group of dead trees south of the Fountain Paint Pots. I positioned the bison in the lower left-hand corner to face into the picture. Snow flurries add drama to the nature story. Positive exposure compensation was needed to render the snow as white. This is a good example of a wildlife scenic. *Canon 100–300mm L lens, 81A filter, Kodachrome 200 film.*

animals may ruin the situation. The wildlife photographer has only limited control over these factors. Yet with patience, luck, and skill, outstanding wildlife photographs can be obtained.

Wildlife photographs can be broken down into three general types. In a wildlife scenic, an animal provides a center of interest in an attractive setting that tells a nature story. The second type is a close-up in which an animal or group of animals occupies most of the frame. This may feature a particularly attractive pose or involve interaction between animals. The third type is a portrait of an animal in which the head occupies most of the frame. All three types, if done well, can be very effective.

The best times to observe and photograph wildlife are early and late in the day. Most animals are much more active near sunrise and sunset. In the middle of the day, animals usually seek the shade and protection of the forest. Also, the lighting is much more pleasing early and late in the day.

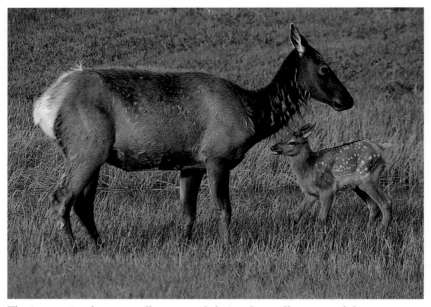

The interaction between elk cows and their calves tells a powerful nature story. A long telephoto lens helped in cropping the image precisely, eliminated distractions from the background, and isolated these two animals from the rest of the herd. The long lens allowed me to stay about 30 yards from the herd, and the cow and calf, because they did not feel threatened, behaved naturally. *Canon 150–600mm L lens, no filters, Kodachrome 200 film.*

Most wildlife in Yellowstone and the Tetons is accustomed to and relatively unafraid of people. With common sense and a few basic techniques, you'll probably be able to safely approach your subjects closely enough to obtain good wildlife photos. Here are a few suggestions:

- Study your subject so that you know its habits and can anticipate its behavior. This will allow you to record more interesting images. Knowledge can be gained from books, but there's no substitute for personal observation and experience.
- Once you find a subject, decide on the position from which you wish to take your photographs. Take into consideration the direction of light, foreground, and background.
- When approaching wildlife, walk slowly and don't try to hide or sneak around. Don't waste money on camouflage clothing or equipment; the animals will probably see you anyway.

- Don't make any sudden movements or noise. If the animal or bird you are trying to photograph looks nervous, stop your approach. Zigzagging rather than walking directly toward the subject is often helpful.
- Stay beyond the range that makes an animal or bird uncomfortable. If you approach closer than this distance, two things can happen: Your subject may run or fly away, or it may charge you. Neither of these results is desirable.
- To avoid disturbing the animal or bird, use a telephoto lens from a safe and legal distance—25 yards in Yellowstone. Before photographing a potentially dangerous animal like a moose, bull elk, bison, or bear, always look for a grove of trees that you can reach quickly if the animal attacks unexpectedly. *Never get between a mother and her young.*
- No photograph is worth harming a bird or animal. Be especially sensitive to the potential trauma caused by approaching a bird on a nest or a newborn animal lying in the grass.
- Be considerate of other photographers. Don't walk in front of their cameras without permission, and be careful not to spook their subjects. You have the right to expect the same consideration.

When photographing an animal or bird, the following artistic guidelines will make your wildlife images more pleasing:

- Make sure all the extremities of the animal or bird are in the picture, unless you're doing a portrait. Pay particular attention to the legs and antlers.
- Try not to center the animal or bird in the frame. Leave more room in front of the animal or bird so that it appears to be moving into the picture.
- Use enough depth of field to make sure that all visible parts of the animal or bird are sharp. This may require f/11 or f/16 with long lenses. More depth of field is required when shooting your subject head-on than from the side.
- Try to capture a "catch light" in the eye if possible. This requires patience, but a highlight in the eye adds life to your subject.
- Look for distractions behind and in front of your subject, such as tree trunks, rocks, or other animals, and do your best to eliminate them by changing your camera position slightly. An out-of-focus background is unavoidable with long lenses and usually

desirable, because it helps make the subject stand out. But an out-of-focus foreground is distracting and should be avoided.

- Try to capture the peak of the action or the best pose. Anticipate what the animal or bird may do. A motor drive may be helpful in recording the precise moment. Fast shutter speeds of $1/250$ to $1/1000$ of a second may be needed to freeze action. You can use speeds as slow as $1/60$ of a second if the animal is motionless.

Elk are by far the most numerous and visible large mammals in Yellowstone and the Tetons. After a mild winter, the Yellowstone herd may swell to thirty thousand animals. Elk can be distinguished from mule deer by their larger size and their cream-colored rump patch. Bull elk grow large antlers during the spring and summer. The velvet is shed from the antlers in autumn, and the bulls lose their antlers in late winter.

The elk herd in the Tetons numbers about ten thousand. These elk are frequently seen, especially at sunrise and sunset, but they are wary and difficult to photograph. The elk in Yellowstone are accustomed to people and easy to photograph, so it's best to concentrate your elk photography there.

Although elk may be seen in many parts of Yellowstone, the best photographic opportunities are in the meadows in the western part of the park, including Norris Meadow, Elk Park, Gibbon Meadow along the Gibbon River, near Old Faithful along the Firehole River, and several meadows just west of Madison Junction along the Madison River. Large numbers of elk also are found in the meadows near Park Headquarters at Mammoth, and many people photograph them there. The elk wander around the terraces, graze on the grounds of the hotel, and look in the windows of the rangers' houses. The setting at Mammoth isn't nearly as photogenic as others, however. This area has a lot of sagebrush, which hides the elk's legs and can be a distracting foreground and background element. You'll likely see elk in many other spots as you drive the Yellowstone Loop Road, but most will be in forested areas, which do not present very good photographic opportunities.

Spring, autumn, and winter are all good times of year to photograph elk in Yellowstone. Early in June, the cows lose their winter coats and may look a little ragged, but by July, they are once again attractive subjects. The cows give birth usually in early June, to one calf, although occasionally twins are born. At this time of year, the cows and calves

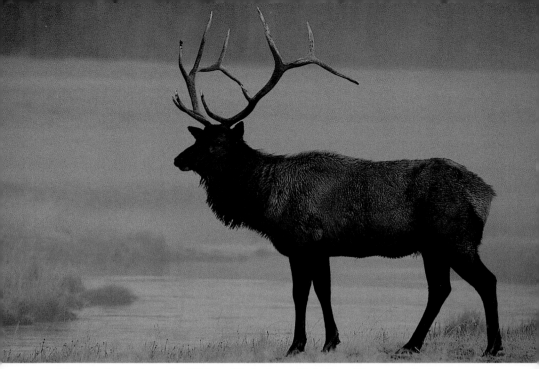

The meadows along the Gibbon, Firehole, and Madison Rivers are the best places to photograph elk because of their pleasing backgrounds. Fog can add mood to both wildlife and scenic pictures. The best times for animal photography are usually early in the morning and late in the afternoon, so fast film and a sturdy tripod are highly recommended. *Canon 150–600mm L lens, no filters, Kodachrome 200 film.*

are separate from the bulls. Mid to late June provides good opportunities to record the antics of the newborn calves as well as interactions between cows and calves. Don't get too close to the calves; the cows may be very protective. You may also see small groups of bulls, which are generally not aggressive in the spring and summer. The bulls' antlers are covered with velvet, and they make very attractive subjects.

In the autumn, the mating activities of the elk can be readily observed and photographed. In the rut, the bulls may be very aggressive, while the cows are usually docile. A single bull may gather a harem of up to twenty cows. The herd master is obsessed with keeping the cows together and other bulls away. He constantly circles his harem, chasing stray cows back into the fold. He bugles frequently to warn other bulls not to approach. Sometimes he fights with another bull to maintain control of his harem. The bull mates with each of the adult females in his harem as she come into estrus. All of these activities make wonderful wildlife photographs.

The elk's light brown coat is close to average reflectivity, so exposure compensation generally isn't necessary when photographing them. However, in the autumn, when the grass is gold, some positive exposure compensation may be necessary if the surroundings are included in the overall meter reading.

In the winter, elk are frequently seen in the parts of Yellowstone where snow is not too deep, such as the thermal areas and the valleys along the northern boundary of the park. Large herds can sometimes be seen on south-facing slopes along the road from Mammoth through the Lamar Valley to Cooke City. A particularly attractive group of bulls is often seen about 5 miles east of Mammoth near the Lava Creek Picnic Area. Bulls keep their antlers most of the winter and begin growing a new set in late April.

The southern Yellowstone and Teton herds migrate to the National Elk Refuge near Jackson, where hay is provided to help them survive the winter. This situation is not very appealing from a photographic standpoint. Too many elk are crowded together in one place, the snow is trampled, and photography must be done from a sleigh that is pulled through the area.

Bison (often mistakenly called buffalo) are probably the next most numerous mammal found in Yellowstone and the Tetons. Once there were an estimated 40 to 60 million bison in the western United States, but by 1900, partially due to the slaughter of these animals by hunters working for the railroads, the bison nearly became extinct. The protection provided by parks such as Yellowstone has allowed the species to survive, and the bison is multiplying rapidly.

A large bull may stand 5 feet high at the shoulder and weigh up to 2000 pounds. The cows are somewhat smaller. Bison are unpredictable and should never be approached closely on foot. Calves, which are tan in color, are born in late May or June.

In Yellowstone, large herds of bison may be seen and photographed in Hayden Valley, the Lamar Valley, and along the Firehole and Madison Rivers, where they sometimes block traffic. Small groups or individuals may be observed almost anywhere in Yellowstone. In the Tetons, you may find bison east of the barns along the Antelope Flats Road and along the Jackson Hole Highway near Cunningham Cabin.

In the winter, bison often frequent Yellowstone's geyser basins, where the snow cover is thin or absent because of the warmth of the ground, making grazing easier. The Lamar Valley, which is consid-

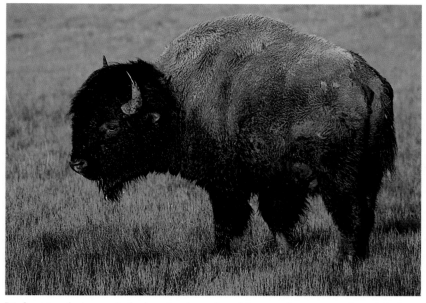

It's best to photograph dark animals such as bison and moose early or late in the day, when the lighting is softer and the sun is low enough to create a highlight in the eye. About half a stop of negative exposure compensation was applied to this picture to keep the bison dark. This image is a good example of a wildlife close-up in which the animal fills most of the frame. I intentionally left more room in front of the bison than behind it. *Tamron 200–400mm lens, no filters, Kodachrome 200 film.*

erably lower in elevation than the Yellowstone Plateau, is another favorite wintering area.

Moose are often seen in both Yellowstone and the Tetons. Moose are large and dark, have long legs, and are usually found singly or in small family groups. The bulls grow large, palmate antlers, which are shed each winter. Moose are primarily browsers, also feeding on aquatic plants, and frequent open streamsides, willow thickets, and forests. Moose of both sexes are unpredictable and may be aggressive.

In Yellowstone, moose are often seen in Willow Park between Norris and Mammoth, along the Lewis River near Lewis Falls, and at Pelican Creek near Fishing Bridge. Over the past few years, I've seen and photographed more moose in the Tetons than in Yellowstone. Good locations in the Tetons include the willow thickets from Oxbow Bend to Jackson Lake Lodge, along the Snake River at Schwabacher Landing and

Blacktail Ponds, and along the eastern portion of the Moose-Wilson Road.

The dark color of bison or moose may require exposure compensation. If you take a meter reading directly off the bison or moose, stop down by at least a half stop. If your reading includes nearby grass or vegetation, less underexposure is needed.

Pronghorn antelope are light tan and white, a little smaller than the average deer, and look very bright or white at a distance. Their keen eyesight and great speed enable them to elude most predators. Bucks have permanent horns, although the outer covering is shed annually. During the mating season in September, pronghorns usually ignore humans and can be easy to photograph. Bucks gather harems of does and chase off all other would-be suitors.

Pronghorns are often seen on the rolling grasslands near the northern boundary of Yellowstone. Look for them west of the town of Gardiner, along a gravel road that starts near the high school. Sometimes they may even be found in the town square. In the Tetons, you may observe pronghorns along the portion of the Teton Park Road between Moose and Jenny Lake. The pronghorns in the Tetons are not as tolerant of photographers as the ones near Gardiner, however. Since the pronghorn is light in color, you'll need to open up by about a half stop when photographing this beautiful animal.

Mule deer can be found just about anywhere in Yellowstone and the Tetons. These beautiful but shy animals are most often seen near dusk and dawn. The mule deer is bigger than the white-tailed or black-tailed deer and has large ears. Bucks have attractive antlers that are shed each winter. Rutting battles usually take place in November and December.

Mule deer in Yellowstone are most often seen near the campground at Mammoth and near Canyon Junction. In the Tetons, they may be found near Signal Mountain and near the town of Jackson. Since the mule deer have average reflectivity, no compensation is needed when photographing them.

Bighorn sheep graze high on the mountain slopes near Mount Washburn during the warmer seasons and are hard to observe, but in November they descend to the lower elevations in the northern part of Yellowstone Park, where food is more accessible. In the winter, groups of bighorn sheep may be seen and photographed along the canyon of the Gardiner River between Gardiner and Mammoth and on McMinn Bench just above and east of the canyon. These regal animals also frequent the Lamar Valley near Soda Butte.

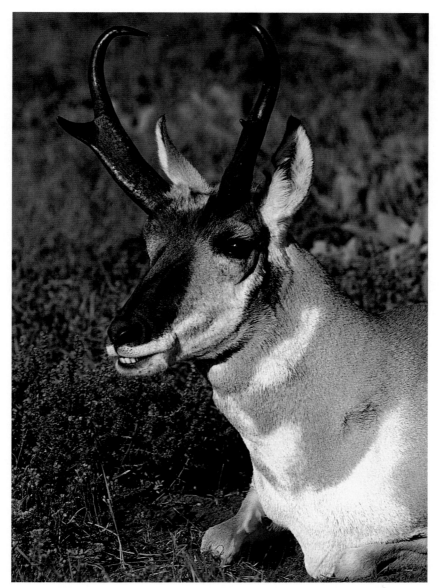

Although the pronghorn antelope is normally one of the wariest animals in Wyoming, the combination of the protection provided by the national parks, a calm individual animal, and the use of proper approach techniques can help you capture some memorable images. This shot, which includes just the head, neck, and shoulders of the animal, is a good example of a wildlife portrait. The highlight in the eye gives more life to the picture. *Minolta 400mm APO lens, no filters, Kodachrome 64 film.*

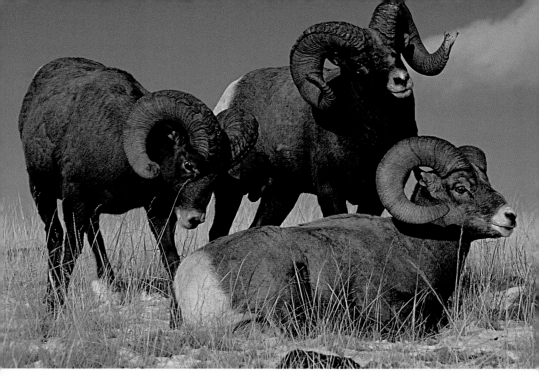

The combination of these three bighorn rams, photographed by my wife, Bonnie, produces a triangular composition that is more interesting than shots of single animals. A zoom lens allowed precise framing of the group, and a motor drive helped record multiple images of the action. Patience is needed when photographing animals and birds. I waited at this position for twenty minutes for something to happen, then I finally gave up and went on to another animal. Bonnie stayed, and when the action started, she got some great shots. *Vivitar Series 1 90–180mm lens, no filters, Kodachrome 64 film.*

In late November and December, rutting battles are waged for the right to breed with the ewes in the herd. The rams often run toward each other, butting horns with earth-shaking impact. Photographing the mating activity of the bighorn sheep is interesting and rewarding. The bighorn sheep in Yellowstone are usually unafraid of people, are not aggressive toward humans, and are relatively easy to approach and photograph. Moderately strenuous trails on the north and south side of McMinn Bench provide access to the habitat of these regal animals; however, the cliffs just east of the Gardiner River are closed.

Bears were once synonymous with Yellowstone. Just a few decades ago, bears were allowed to beg along the roads and were numerous and visible. However, this situation was not good for the bears' health and was dangerous for the visitors. Yellowstone changed its policy in the 1970s, removing bears to the backcountry when they showed up along the roads and eliminating repeat offenders.

Both black bears and grizzlies are found in Yellowstone, although they are seldom seen near the roads. Black bears are not always black but may be brown or even blond. Grizzly bears are considerably larger than black bears and have a pronounced hump on the back and a dished face. Bears are omnivorous, eating both plant and animal food. Both black bears and grizzlies enter dens in October and November and emerge in the spring.

In Yellowstone, you're most likely to see a bear on Dunraven Pass between Canyon and Tower or near the road between Tower and Mammoth. In the Tetons, you may find black bears near Signal Mountain. If you're lucky enough to observe a bear, park regulations dictate that you stay at least 100 yards from the animal. When photographing a black bear, you should stop down by at least half a stop. Light brown bears require no compensation.

Coyotes are frequently seen in Yellowstone and the Tetons. Coyotes are gray and about the size of a medium-size dog. They are primarily scavengers but also hunt mice and are found in a wide range of

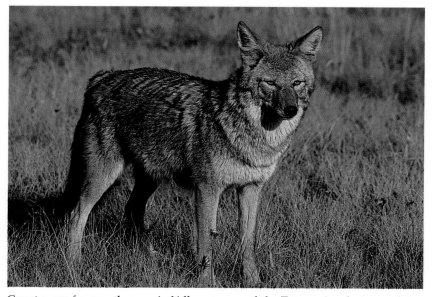

Coyotes are frequently seen in Yellowstone and the Tetons. An alert pose, late-afternoon light, tight cropping, and a good background all combine to make this image successful. Since the subject and background were both of average reflectance, no exposure compensation was needed. *Canon 150–600mm L lens, no filters, Kodachrome 200 film.*

habitats, including woodlands and grasslands. If you spot a carcass, especially in the winter, coyotes likely will be in the vicinity. Coyotes are of average reflectance and require no exposure compensation.

Wolves were native to northwestern Wyoming, but by 1930 they had been hunted to extinction in the area. Wolves were reintroduced to Yellowstone in the mid-1990s, and since then they've multiplied rapidly. Packs of wolves may be seen at a distance, especially in the Lamar Valley, but you'd be extremely fortunate to get close enough to get good photographs of these shy animals. (Despite common beliefs, wolves are not considered dangerous to humans.) Wolves are larger than coyotes and are mostly gray, although some have very light or dark coloration.

The beautiful trumpeter swan is frequently seen in both Yellowstone and the Tetons. These giant swans were once in danger of extinction but are making a strong comeback. Trumpeters nest in June, and the cygnets usually hatch about the first of July.

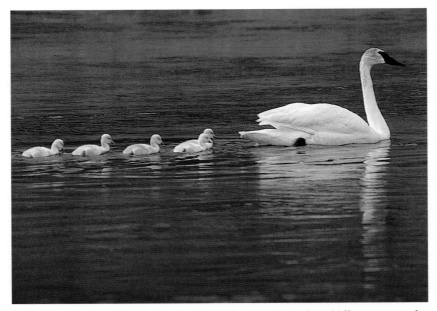

Trumpeter swans may be seen on many rivers and ponds in Yellowstone and the Tetons. In late June and early July, cygnets hatch and paddle along behind their parents. Images that include parents and young are favorites with viewers. *Canon 150–600mm L lens, no filters, Kodachrome 200 film.*

In Yellowstone, look for trumpeters on the Madison River along the road to the West Entrance and on Swan Lake just south of the Golden Gate on the road between Mammoth and Norris. In the winter, trumpeter swans are often seen on the Yellowstone River in Hayden Valley and along the Firehole River between Madison and Old Faithful. In the Tetons, look for trumpeters on Christian Pond just east of Jackson Lake Lodge and on Flat Creek just north of Jackson, where a wildlife refuge has been established to protect them.

Since trumpeter swans are white and the water around them is usually dark, obtaining proper exposure is a problem. Separating the black bill from the dark water is especially difficult. It's best to meter on the birds and then open up about one and a half stops. Overcast conditions may help decrease the contrast between the swans and the water.

Many other animals and birds that make good photographic subjects can be found in Yellowstone and the Tetons, including beavers, river otters, pine martens, ground squirrels, chipmunks, great gray owls, Clark's nutcrackers, great blue herons, sandhill cranes, Canada geese, and white pelicans. Keep your eyes open and your long lens handy, and you'll be rewarded with interesting images.

Wildflowers

The sagebrush flats of Jackson Hole, the mountain slopes of the Teton Range, and the marshy areas around the geyser basins of Yellowstone are all good places to observe and photograph wildflowers during the summer months. Flowering begins at the lower elevations in June and moves up the mountainsides as summer progresses, continuing into September.

Some of the best places to find fields of flowers in Jackson Hole are the meadows along the Teton Park Road between Moose and Signal Mountain and the meadows between Jackson Lake Lodge and Colter Bay on the road to Yellowstone. Balsamroot is prolific here in early and mid-June, giving way to Indian paintbrush, lupine, wild geranium, and wild buckwheat in July. At higher elevations, glacier lilies, Indian paintbrush, and pink monkeyflowers brighten the alpine meadows and streamsides.

In Yellowstone, the warm ground in the geyser basins allows showy flowers like fringed gentian to flourish. You'll see them along the boardwalks in the Upper Geyser Basin, Black Sand Basin, and Midway Geyser Basin. The marshy meadows caused by runoff from the thermal features support yellow monkeyflowers, elephantella, and prairie smoke. The marshes just south of Fountain Paint Pots are one of the best locations for these flowers.

Picking flowers is illegal in national parks and may damage or kill the plant. In a field of flowers, some trampling may be unavoidable, but keep damage to a minimum. You can include the flowers in the foreground of a landscape or fill the frame with a flower or group of flowers. When photographing landscapes with flowers in the foreground, effective images can be produced by using a wide-angle lens,

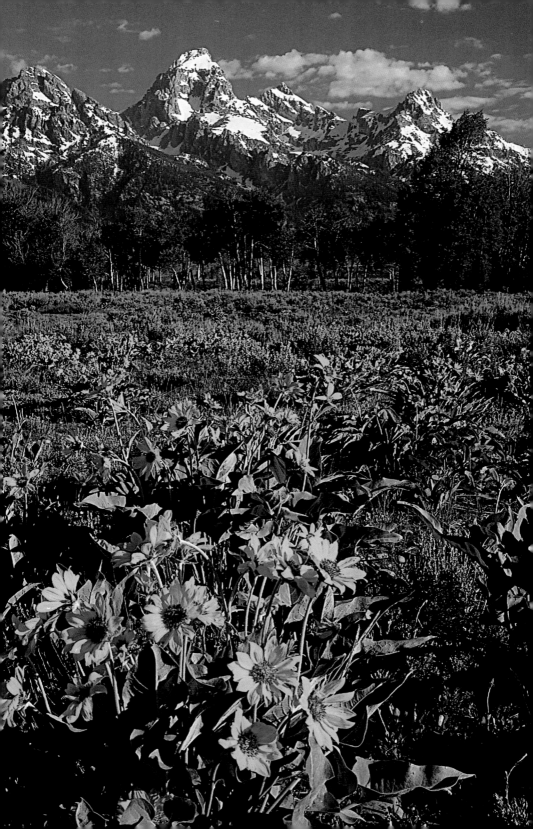

Many species and colors of Indian paintbrush are found in the Rocky Mountains from Colorado to Canada. This image was shot on a cloudy but bright day with little wind. The soft green background complements the brilliant red of the flower. I tilted the camera slightly from the vertical to present the stem on a slight diagonal. *Minolta 70–210mm lens, close-up lens, enhancing filter, Fuji Velvia film.*

focusing at the hyperfocal distance, and getting as close to the flowers as your depth of field will allow.

To take close-ups of flowers, you need close-up lenses, extension tubes, bellows, or a macro lens. Choose an individual flower or group of flowers that makes a good composition, and fill the frame. Showy and colorful flowers make the best subjects. The blooms should be in prime condition.

It's best to render all parts of the blossom or blossoms sharp. This usually requires an aperture of at least f/16, and sometimes f/22 or f/32. With ISO 50 or 100 films, this usually means a shutter speed of ⅛ of a second or slower. At these slower speeds, a tripod is generally needed to avoid camera shake, as well as to maintain constant framing of the subject. A tripod that goes flat or low to the ground is a distinct advantage when photographing flowers.

Previous page: A wide-angle lens was used for these flowers in the foreground of a mountain landscape and was focused at the hyperfocal distance to obtain sharpness from 4 feet to infinity. The flowers were placed in the lower left to balance the Cathedral Group in the upper right. *Minolta 35–70mm lens, polarizing and enhancing filters, Fuji Velvia film.*

The lighting and wind conditions determine how to approach a flower close-up. If the sun is out, even at f/16 or f/22 the corresponding shutter speeds will usually be high enough to obtain sharp pictures unless it's windy. Under sunny conditions, bright leaves, sticks, or pebbles in the background may be distracting. Change your camera position slightly or remove the offending materials. If necessary, you can darken the background by casting a shadow on it with your body, an umbrella, or a camera pack.

Overcast conditions provide soft, even lighting, which produces attractive close-ups of flowers. But with the lower light intensity, you'll need a slower shutter speed. To photograph flowers successfully under overcast conditions, there must be little or no wind; if the flower moves during the exposure, your image will not be sharp. You may need a great deal of patience to successfully photograph flowers with available light if any breeze is present. A faster film in the ISO 100 or 200 range will help you under these conditions.

A soft, natural background usually enhances the photographic presentation of the flower. If you position your camera at the level of the flower, the background will usually be farther away than if you point down onto the flower. This will cause the background to be com-

The wind was too strong to attempt an available-light shot, so I used a strobe off-camera. I placed the flash slightly behind and to the right of the flower and a reflector on the opposite side to soften the lighting. Although the flower stands out well from the dark background, I prefer natural backgrounds when conditions permit. *Minolta 100mm bellows lens, electronic flash and reflector, Kodachrome 64 film.*

This photograph, taken by my wife, Bonnie, uses selective focus, which creates a dreamy, ethereal feeling. For such images, a long lens with shallow depth of field is mandatory. The diaphragm is thrown wide open to render most of the picture soft and out of focus, with only one flower in sharp focus. Try this technique as a change of pace. *Canon 100–300mm lens, close-up lens, enhancing filter, Fuji Velvia film.*

pletely out of focus, allowing the flower to stand out. The soft green background provided by out-of-focus grass is ideal.

If too much wind exists for pictures with available light, you can use electronic flash as a source. With ISO 50 film at f/22, the light from the flash will overpower the ambient light. Since the duration of the flash is about $\frac{1}{1000}$ of a second, the effective exposure on the flower is $\frac{1}{1000}$ second at f/22.

The flash is best used off-camera to create sidelighting or back-lighting. Flash provides very contrasty lighting in which the side of the flower next to the flash is brilliantly lit and the opposite side is very dark. To correct this, a reflector placed on the side of the flower opposite the flash will bounce light back onto the dark side. You can buy a fold-up reflector or make your own by covering a piece of cardboard with aluminum foil.

Exposure can be controlled by moving the flash closer to or farther from the flower. A weak manual strobe works better than a powerful dedicated automatic flash for this purpose, although most dedicated strobes can be switched to manual and low power. This technique results in a razor-sharp, well-lit picture of the flower, but the background is usually dark. The automatic exposure mode on your camera

won't work when using this technique, because the dark background throws off the reading and results in overexposure. If the wind is too strong for natural light, you may have to put up with dark backgrounds if you want pictures of the flowers.

Another technique sometimes used for photographing flowers is selective focus. This method requires a very shallow depth of field, using a telephoto lens and shooting with the aperture as wide open as possible. Place a group of flowers almost against the front of the lens, and focus on a flower several feet behind it. This results in masses of soft color surrounding one blossom that is sharp. Since a wide aperture is used for selective focus, the shutter speed will be very fast. This technique can also be used for other subjects, such as autumn leaves.

Resources and References

RESOURCES

Yellowstone National Park
Park Headquarters
P.O. Box 168
Yellowstone National Park,
 WY 82190
(307) 344-7381
Park information, visitor center.

The Yellowstone Association
P.O. Box 117
Yellowstone National Park,
 WY 82190
(307) 344-2293
*Park information, books
(list available on request).*

TW Services
Yellowstone National Park,
 WY 82190
(303) 297-2757
(307) 344-7311
Lodging, snowcoach reservations.

Flagg Ranch
P.O. Box 187
Moran, WY 83013
(307) 543-2861
(800) 443-2311
*Lodging and services at South
Entrance Campground.*

Grand Teton National Park
Park Headquarters
P.O. Drawer 170
Moose, WY 83012
(307) 733-2880
Park information, books.

Jackson, Wyoming
Information Center
535 N. Cache
Jackson, WY 83001
(307) 733-3316

REFERENCES

The Yellowstone Association is a nonprofit organization with an extensive list of books, brochures, and maps that you can purchase by mail. For a free brochure, write to the Yellowstone Association, P.O. Box 117, Yellowstone National Park, WY 82190, call (307) 344-2486, or visit the web site www.yellowstoneassociation.org.

For a complete list of books and maps about the Tetons, write to Grand Teton Natural History Association, P.O. Drawer 170, Moose, WY 83012.

Products and Services

The following are suppliers of products and services you may need during your photographic trip to Yellowstone and the Tetons. The merchants listed are not necessarily the only good sources of these products or services. Phone numbers are subject to change.

WEST YELLOWSTONE, MONTANA

Motels

Best Western Executive Inn
236 Dunraven
West Yellowstone, MT 59758
(406) 646-7681
(800) 528-1234

Best Western Weston Inn
103 Gibbon Ave.
West Yellowstone, MT 59758
(406) 646-7373
(800) 528-1234

Brandin' Iron Inn
201 Canyon
West Yellowstone, MT 59758
(406) 646-9411
(800) 217-4613

Comfort Inn
638 Madison Ave.
West Yellowstone, MT 59758
(406) 646-4212

Days Inn
118 Electric
West Yellowstone, MT 59758
(406) 646-7656
(800) 548-9551

Holiday Inn Sunspree Resort
315 Yellowstone Ave.
West Yellowstone, MT 59758
(406) 646-7365

Pony Express Motel
4 Firehole Ave.
West Yellowstone, MT 59758
(406) 646-7644

Roundup Motel
3 Madison Ave.
West Yellowstone, MT 59758
(406) 646-7301

Stagecoach Inn
209 Madison Ave.
West Yellowstone, MT 59758
(406) 646-7381
(800) 842-2882

Restaurants

The Three Bears
205 Yellowstone Ave.
West Yellowstone, MT 59758
(406) 646-7811

Pete's Pizza Co.
104 Canyon
West Yellowstone, MT 59758
(406) 646-7820

Chinatown
100 Madison Ave.
West Yellowstone, MT 59758
(406) 646-7088

Silver Spur Cafe
20 Firehole Ave.
West Yellowstone, MT 59758
(406) 646-7013

Ernie's Bighorn Deli
406 Highway Ave.
West Yellowstone, MT 59758
(406) 646-9467

Trapper Family Restaurant
315 Madison Ave.
West Yellowstone, MT 59758
(406) 646-9375

Outpost Restaurant
115 Yellowstone Ave.
West Yellowstone, MT 59758
(406) 646-7303

Cappy's Bistro
104 Canyon
West Yellowstone, MT 59758
(406) 646-9537

Campgrounds

Brandin' Iron
201 Canyon
West Yellowstone, MT 59758
(406) 646-9411
(800) 217-4613

Hideaway RV Campground
Gibbon and Electric
West Yellowstone, MT 59758
(406) 646-9049

Rustic RV Campground
634 Hwy. 20 West
West Yellowstone, MT 59758
(406) 646-7387

Yellowstone Grizzly RV Park
210 S. Electric
West Yellowstone, MT 59758
(406) 646-4466

Yellowstone Park KOA
West of West Yellowstone
West Yellowstone, MT 59758
(406) 646-7606

Camera Stores

Camera America
28 Madison Ave.
West Yellowstone, MT 59758
(406) 646-7990

Elk Mountain Photo
29 Canyon
West Yellowstone, MT 59758
(406) 646-9760

Madison Crossing Photo
121 Madison Ave.
West Yellowstone, MT 59758
(406) 646-4800

Other Places of Interest
National Geographic Theater
(IMAX)
101 S. Canyon
West Yellowstone, MT 59758
(406) 646-4100

Film of Yellowstone.

Grizzly Discovery Center
111 S. Canyon
West Yellowstone, MT 59758
(406) 646-7001

Live bears and wolves.

Museum of the Yellowstone
124 Yellowstone Ave.
West Yellowstone, MT 59758
(406) 646-7814

Historical and wildlife exhibits.

Eagle's Sporting Goods
9 Canyon
West Yellowstone, MT 59758
(406) 646-7521

GARDINER, MONTANA

Motels
Super 8 Motel
Hwy. 89
Gardiner, MT 59030
(406) 848-7401

Best Western Motel
Hwy. 89
Gardiner, MT 59030
(406) 848-7311
(800) 528-1234

Absaroka Lodge
Hwy. 89
Gardiner, MT 59030
(406) 848-7414

Restaurants
Town Cafe
Hwy. 89
Gardiner, MT 59030
(406) 848-7322

Yellowstone Mine
Hwy. 89
Gardiner, MT 59030
(406) 848- 7336

Outlaws Pizza
Hwy. 89
Gardiner, MT 59030
(406) 848-7733

Cecil's Restaurant
3rd and Park
Gardiner, MT 59030
(406) 848-7561

Campgrounds
Rocky Mountain Camp
Hwy. 89
Gardiner, MT 59030
(406) 848-7251

Yellowstone RV Park
N. of Gardiner
Gardiner, MT 59030
(406) 848-7496

Camera Stores
Gardiner Drug
Hwy. 89
Gardiner, MT 59030
(406) 848-7541

High Country Photo
Hwy. 89
Gardiner, MT 59030
(406) 848-9425

GRAND TETON NATIONAL PARK

Lodges and Motels
Grand Teton Lodge Co.
Moran, WY 83013
(307) 543-2811
(307) 543-3100

Jackson Lake Lodge,
Colter Bay Village

Jenny Lake Lodge
Moose, WY 83012
(307) 733-4647

Signal Lake Lodge
P.O. Box 50
Moran, WY 83013
(307) 543-2831

Hatchet Motel
P.O. Box 316
East Hwy. 287
Moran, WY 83013
(307) 543-2413

JACKSON, WYOMING

Motels
Flat Creek Motel
P.O. Box 20013
Jackson, WY 83001
(307) 733-5276
(800) 438-9338

49'er Inn & Suites
W. Pearl and Jackson
Jackson, WY 83001
(307) 733-7550
(800) 451-2980

Antler Inn
W. Pearl and Cache
Jackson, WY 83001
(307) 733-2535
(800) 522-2406

Best Western at Jackson
80 Scott Lane
Jackson, WY 83001
(307) 733-9703
(800) 528-1234

Days Inn
350 S. Hwy. 89
Jackson, WY 83001
(307) 733-0033
(800) DAYS INN

Motel 6
600 S. Hwy. 89
Jackson, WY 83001
(307) 733-1620
(800) 466-8356

Super 8
750 S. Hwy. 89
Jackson, WY 83001
(307) 733-6833
(800) 800-8000

The Wort Hotel
Broadway and Glenwood
Jackson, WY 83001
(307) 733-2190

Anvil Motel
Cache and Gill
Jackson, WY 83001
(307) 733-3668

Restaurants
Wagon Wheel
455 North Cache
Jackson, WY 83001
(307) 733-2492

Anthony's Italian Restaurant
50 S. Glenwood
Jackson, WY 83001
(307) 733-3717

Teton Steakhouse
40 W. Pearl
Jackson, WY 83001
(307) 733-2639

Chinatown Restaurant
850 W. Broadway
Jackson, WY 83001
(307) 733-8856

Bubba's Bar-B-Que
515 W. Broadway
Jackson, WY 83001
(307) 733-2288

The Bunnery
130 N. Cache
Jackson, WY 83001
(307) 733-5474

Merry Piglets
160 N. Cache
Jackson, WY 83001
(307) 733-2966

Mama Inez
380 W. Pearl
Jackson, WY 83001
(307) 739-9166

Mangy Moose
Teton Village
Jackson, WY 83001
(307) 733-9166

Billy's Giant Hamburgers
55 N. Cache
Jackson, WY 83001
(307) 733-3279

Campgrounds
Wagon Wheel
N. Hwy. 89
Jackson, WY 83001
(307) 733-2357
Northside of Jackson.

Grand Teton RV
E. Hwy. 287
Jackson, WY 83001
(800) 563-6469
Just east of Moran.

KOA of Moran Junction
E. Hwy. 287
Jackson, WY 83001
(307) 543-2483

Just east of Moran.

Teton Village KOA
Moose-Wilson Rd.
Jackson, WY 83001
(307) 733-5354

South of Teton Village.

Camera Stores
Broadway 1 Hour Photo
130 W. Broadway
Jackson, WY 83001
(307) 733-6453

DD Camera Corral
60 S. Cache
Jackson, WY 83001
(307) 733-3831

Grand Teton Photo
49 W. Broadway
Jackson, WY 83001
(307) 733-3198

Mountain Camera Supply
180 W. Broadway
Jackson, WY 83001
(307) 733-7998

Camera America
365 W. Broadway
Jackson, WY 83001
(307) 733-4962

Other Places of Interest
National Museum of Wildlife Art
N. Hwy. 89
Jackson, WY 83001
(307) 733-5771

Jackson Historical Society
and Museum
105 N. Glenwood St.
Jackson, WY 83001
(307) 733-2414

Gart Sports
455 W. Broadway
Jackson, WY 83001
(307) 733-4449

Snowshoe rental.

Wildernest Sports
Teton Village
Jackson, WY 83001
(307) 733-4297

National Elk Refuge
2755 Rungius Rd.
Jackson, WY 83001
(307) 733-0277
(800) 225-5355

Sleigh rides.

National Fish Hatchery
N. Hwy. 89
Jackson, WY 83001
(307) 733-2510

OTHER SUPPLIERS

Camera Stores
F/11 Photographic Supplies
16 E. Main St.
Bozeman, MT 59715
(800) 548-0203

Full line of cameras, lenses, and film.

BIBLIOGRAPHY

Bauer, C. Max. *Yellowstone: Its Underworld.* University of New Mexico Press, 1948.

Brock, Thomas D. *Life at High Temperatures.* Yellowstone Association of Natural History, Sciences, and Education, 1994.

Craighead, Karen. *Large Mammals of Yellowstone and Grand Teton National Parks.* Craighead, 1978.

Fryxell, Fritiof. *The Tetons: Interpretations of a Mountain Landscape.* University of California Press, 1953.

Harry, Bryan. *Teton Trails: A Guide to the Trails of Grand Teton National Park.* Grand Teton Natural History Association, 1966.

Lange, Joseph K. *How to Photograph Landscapes.* Stackpole Books, 1998.

Love, J. D., and Reed, John C., Jr. *Creation of the Teton Landscape.* Grand Teton National History Association, 1976.

National Park Service. *Grand Teton: Official National Park Handbook.* National Park Service, 1984.

Schullery, Paul. *The Bears of Yellowstone.* Yellowstone Library and Museum Association, 1980.

Shaw, Richard J. *Wildflowers of Yellowstone and Grand Teton National Parks.* Wheelwright Lithographing Company, 1956.

Wuerthner, George. *Yellowstone: A Visitor's Companion.* Stackpole Books, 1992.